Little
LANDSCAPES

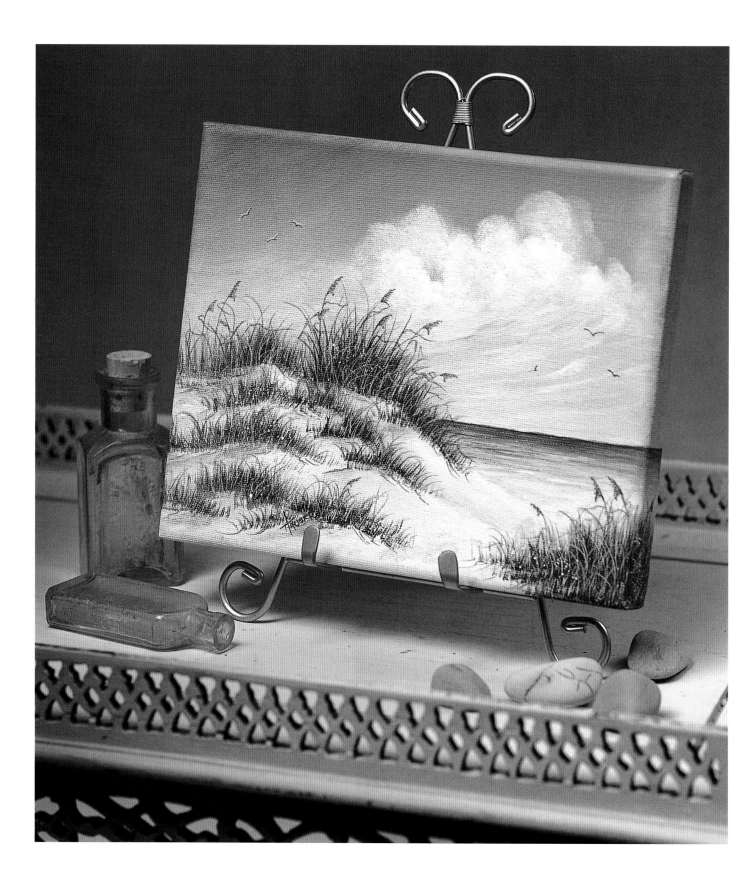

Little
LANDSCAPES

Priscilla Hauser

STERLING

New York / London
www.sterlingpublishing.com

Prolific Impressions Production Staff:
Editor in Chief: Mickey Baskett
Copy Editor: Ellen Glass
Graphics: Dianne Miller, Karen Turpin
Styling: Lenos Key
Photography: Jerry Mucklow
Administration: Jim Baskett

Every effort has been made to insure that the information presented is accurate. Since we have no control over physical conditions, individual skills, or chosen tools and products, the publisher disclaims any liability for injuries, losses, untoward results, or any other damages which may result from the use of the information in this book. Thoroughly read the instructions for all products used to complete the projects in this book, paying particular attention to all cautions and warnings shown for that product to ensure their proper and safe use.

STERLING and the distinctive Sterling logo are registered trademarks of
Sterling Publishing Co., Inc.

Library of Congress Cataloging-in-Publication Data

Hauser, Priscilla.
 Little landscapes / Priscilla Hauser.
 p. cm.
 Includes index.
 ISBN 978-1-4027-5269-8
 1. Landscape painting--Technique. 2. Miniature painting--Technique. I. Title.
 ND1342.H38 2008
 751.45'436--dc22

2008007159

10 9 8 7 6 5 4 3 2 1

Published by Sterling Publishing Co., Inc.
387 Park Avenue South, New York, NY 10016
© 2008 by Prolific Impressions, Inc.
Distributed in Canada by Sterling Publishing
c/o Canadian Manda Group, 165 Dufferin Street
Toronto, Ontario, Canada M6K 3H6
Distributed in the United Kingdom by GMC Distribution Services
Castle Place, 166 High Street, Lewes, East Sussex, England BN7 1XU
Distributed in Australia by Capricorn Link (Australia) Pty. Ltd.
P.O. Box 704, Windsor, NSW 2756, Australia

Sterling ISBN 978-1-4027-5269-8

For information about custom editions, special sales, premium and corporate purchases, please contact Sterling Special Sales Department at 800-805-5489 or specialsales@sterlingpublishing.com.

About the Author

Priscilla Hauser

Priscilla Hauser

She's called the "First Lady of Decorative Painting," and with good reason. Inspired by Priscilla's efforts and dreams, as well as her ability to draw people together, 21 people joined her for the first meeting of the National Society of Tole & Decorative Painters on October 22, 1972. The organization has grown and thrived, and so has Priscilla.

Priscilla began painting in the early 1960s, after taking tole painting classes at a YMCA in Raytown, Missouri. Since then, she has become a world renowned teacher, author, and the decorative painting community's ambassador to the world. Besides teaching classes and workshops, Priscilla has used print and electronic media to share her knowledge and irresistible enthusiasm. Books, magazine articles, videos, and television have spread her techniques for decorative painting around the world.

The successful results of her teaching method have led to an accreditation program for teachers who have demonstrated mastery of her techniques. Priscilla has taught in Canada, Japan, Argentina, and The Netherlands, and throughout the United States. She has an extensive teaching program at Priscilla's Little Tole House, Tulsa, OK.

For information about Priscilla Hauser Painting Seminars, you can contact Priscilla as follows:
Priscilla Hauser
P.O. Box 521013
Tulsa, OK 74152
Telephone: (918) 743-6072
Fax: (918) 743-5075
Website: www.priscillahauser.com
Email: phauser376@aol.com

Acknowledgments

Thank you to the following manufacturers for their generous contributions of products to paint the landscapes in this book:

Houston Art, Inc. 10770 Moss Ridge Road, Houston, TX 77043 www.houstonart.com

Masterson Art Products, P.O. Box 11301, Phoenix, AZ 85017 www.mastersonart.com

Daler Rowney, 2 Corporate Drive, Cranbury, NJ 08512-9584

Tara Materials, Fredrix Artist Canvas, P.O. Box 646, Lawrenceville, GA 30046, www.fredrixartistcanvas.com

Plaid Enterprises Inc., Norcross, GA 30091, www.plaidonline.com, for their contribution of FolkArt® Artists' Pigments.

Dedication

This book is possible because of the beautiful work of my long time friend and colleague, Judy Kimball. Judy covered for me during a family medical emergency. Of course, credit also goes to my paint team: Sue Sensintaffar, Collette Ralston, Joyce Beebe, and Jan Alphin. Thank you, *Priscilla*

Contents

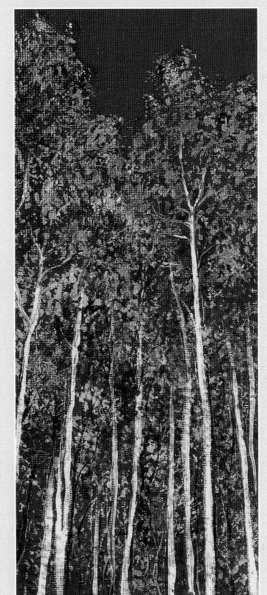

When I was a child, I loved to play with dollhouses and miniature furniture. As a matter of fact, I have always been fascinated by everything that is tiny. Maybe that is why I enjoy doing miniature canvas paintings.

This book contains 15 little landscape paintings for you to enjoy painting. Painting on a small scale is a little different than painting large canvases, but this book will walk you through every aspect of the painting process. In the *Painting Landscape Elements* section you will learn how to paint skies, clouds, ground, trees, etc. Then when you get to the projects section, you will learn how to put all these elements together into a painting. Each painting projects is broken down into step by step worksheets so that you can learn how to place the background, foreground and details.

I have included patterns for each of projects that we present. Please feel free to use these patterns. You can transfer them onto your canvas, or simply sketch the design free-hand onto your canvas. When you get accomplished enough with painting the various elements, you can simply draw your horizon line and then begin painting your own personal view of your world.

Wonderful little paintings on canvas to display on end tables, bookshelves, coffee tables or anywhere they can be picked up and viewed at close range.

If I were to define the size of the mini, I would say it would be a painting smaller than 5" x 7". However, miniature can go to an absolutely minute size and be perfectly magnificent in every detail. I like to call mini paintings "table art" and display them on end tables, bookshelves, coffee tables or anywhere they can be picked up and viewed at close range.

One of my favorite collections of miniature art was done for my husband Jerry by my dear friend and colleague Judy Kimball. Judy painted the farmhouse where Jerry was born in Northern Wisconsin. The farmhouse was painted a pretty good size, and then she painted miniatures of all the things that Jerry loved so from the farm. She painted the outhouse-yes! – the old apple tree, the barn and other farm elements, which we hung surrounding the larger painting of the house. This collection of minis, along with the painting of the house, is a treasure of memories.

Painting miniature landscapes really isn't difficult at all, if you can **see.** Now, that's important. I recommend using a precision binocular headband magnifier, which is what I use when I paint. The headband magnifier gives you terrific magnification and leaves your hands free for painting. I had to get used to it in the beginning, but I just love it now.

TIP: *Priscilla uses a precision binocular headband magnifier when painting the small landscapes.*

Still think you can't paint a mini? Then enlarge the pattern and do it on a larger canvas. You see, I've got you covered.

Above all . . . enjoy!

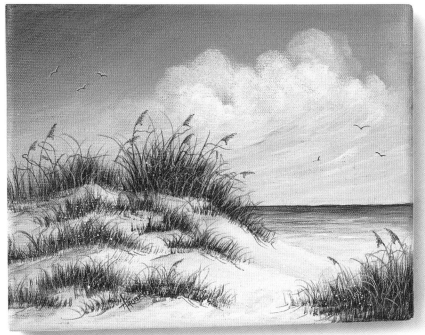

Priscilla's Beach Before the Storm. Instructions begin on page 102.

General Supplies

The brilliance of the colors you use for painting your mini landscapes is the most important factor in their effect on the viewer. So, be selective when choosing your paints. The projects and the worksheets in this book were created with artist pigment acrylics, which are equivalent to tube acrylics in the quality of their ingredients.

While the painting projects in this book were done in acrylics, it would be easy to convert them into another medium. These paintings can be done in acrylics, oils, and, yes, even in watercolors. Use the same sizes and types of brushes, and follow the same directions for mixing colors. The choice is yours; paint with the medium you enjoy most.

Use the best paints and brushes. They are easier to work with and give you much better results for all the time and dedication you devote to your art.

Artists' Acrylic Paints

Artist pigment acrylics and tube acrylics have true pigment names, like oil paints, and the paints are true, undiluted colors, with no white or other colors added.

Artist pigment acrylic paints are packaged in plastic squeeze bottles and are available at art supply and craft stores. You can blend them and move them in much the same way as oil paints by using acrylic painting mediums.
Bottled craft acrylics are very different from the pigment paints. Their colors are already mixed and blended by the manufacturer, so you cannot achieve true colors when you mix them for your landscape paintings.

Mediums for Artist Pigment Acrylics

Mediums are gel or liquid vehicles that are mixed with acrylic paint to help the artist create special effects, such as glazing or antiquing, or to allow the paint be applied very smoothly. Mediums can be helpful, but are not always necessary; for example, you can use water to create washes. Look for mediums where paints are sold. It is best to use mediums and paints from the same manufacturer.

Floating Medium
This medium is used to thin paint so it can be used for floating a color. To use floating medium, fill the brush with the medium. Touch one corner of the bristles into the color and blend on the palette. Brush the color along an edge of the design element to create shading or highlighting.

Blending Medium
Blending medium keeps the paint wet and moving. To use it, paint the medium onto the surface. Add the colors to be blended to the wet surface, and blend them immediately while the medium is wet.

Glazing Medium
This medium is used to thin paint to a very liquid, transparent consistency that can be used for antiquing or flyspecking. Mix the medium with the paint on the palette or in a small container. Glazing medium can also be used as a substitute for floating medium. It works in the same way.

Color Chart

These artist pigment acrylic colors are used for painting the landscapes in this book. Each project begins with a list of the colors used for painting that miniature landscape.

Alizarin Crimson

Aqua

Asphaltum

Burnt Sienna

Burnt Umber

Cobalt Blue

Dioxazine Purple

Hauser Green Light

Hauser Green Medium

Light Red Oxide

Medium Yellow

Naples Yellow

Olive Green

Payne's Gray

Prussian Blue

Pure Black

Pure Orange

Raw Sienna

Red Light

Teal Green

Titanium White

True Burgundy

Turner's Yellow

Warm White

Yellow Light

Yellow Ochre

Brushes

There are many types of brushes because different-shaped brushes create different effects. Brushes are your most important tools, so buy the best and take good care of them. The brushes needed for a particular project are listed with the project instructions.

Please purchase the very best brushes money can buy. They are your tools-the things you paint with. Occasionally a student says, "Priscilla, I don't want to buy a good brush until I know I can paint." I always tell my students they won't be *able* to paint if they don't begin with a good brush.

Flat Brush

Flat brushes are designed for brush strokes and blending. These brushes are used most frequently in painting the designs. Project instructions include a list of flat brush sizes that were used to create the original painting; simply choose the size that works best for you in any particular area. It is a good idea to use the largest brush that is comfortable.

Wash Brush

A 1" wash brush is used to lay in large areas of color, especially for skies and backgrounds, and to blend colors.

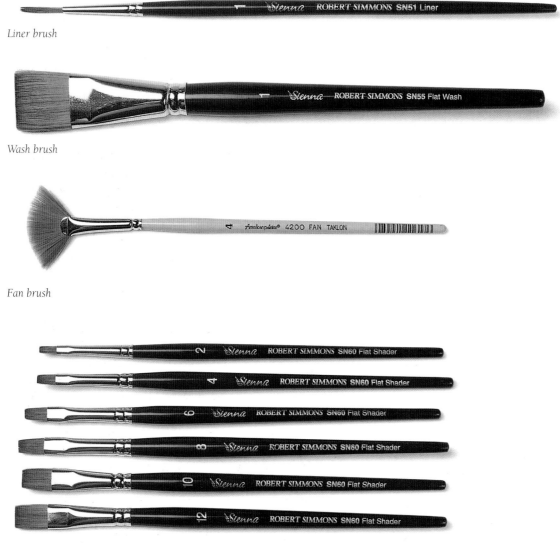

Liner brush

Wash brush

Fan brush

Flat brushes in a variety of sizes.

Liner Brush

Liner brushes are very small round brushes with long hairs that come to a sharp point. They are used for fine line work, painting details, and outlining.

Fan Brush

The spread-out bristles of the fan brush create wispy, feathery strokes that are perfect for grasses or distant trees in the landscape.

Scrubby or Scumbling Brush

An old, worn-out brush that no longer holds its proper shape is ideal for creating the random, irregular shapes of foliage, or for scrubbing paint into the canvas for textural or atmospheric effects.

BRUSH CARE

Clean your brushes thoroughly and store them properly to keep them in excellent condition.

1. Gently flip-flop the brush back and forth in water until all the color is removed. Rinse it thoroughly in clean water. Never slam brushes into a container and stir them.
2. Work brush cleaner through the hairs of the brush in a small dish. Wipe the brush on a soft, absorbent rag. Continue cleaning until there is no trace of color on the rag.
3. Shape the brush with your fingers and store it where nothing can distort the shape of the hairs. Rinse the brush in water before using it again.

Canvas

The mini landscapes in this book are painted on **stretched canvas** or **canvas board**. Painters' canvas is a tightly-woven cotton or linen fabric that is stretched over a wooden framework and stapled in place. The fabric surface is prepared by priming with a base coat of acid-free white gesso, which seals the surface and does not allow the canvas to absorb paint. Stretched canvas can be purchased in a variety of sizes and shapes that are pre-primed and ready to paint. Some of the designs are painted on a **wrap-around canvas** that is stretched over a 1½" deep stretcher bar and secured invisibly on the back, rather than stapled to the sides. The design is continued right around the edges, and the finished piece does not need to be framed.

Other Supplies

These supplies are not listed in the individual project instructions, but you will need to gather them for every painting session.

Fine Grade Sandpaper – Use fine grade sandpaper to smooth the surface of the primed canvas before you begin to paint.

Tack Rag – A tack rag is a piece of cheesecloth or other soft cloth that has been treated with a mixture of varnish and linseed oil to make it sticky. Use it for wiping sanded surfaces to remove all dust particles. Store the tack rag in a tightly sealed jar.

Tracing Paper – I use a very thin, transparent tracing paper and a pencil for tracing designs.

Graphite Paper or Transfer Paper – Use gray transfer paper to transfer the designs to the canvas surface.

Stylus – Use a stylus tool for transferring a traced design to the canvas surface. You may also use a pencil or a ballpoint pen that no longer writes.

Chalk or Charcoal Pencil – Use as an alternative to transfer paper.

Palette Knife – Use a flexible steel palette knife with a straight blade for mixing and moving paint on your palette or mixing surface.

Piece of Glass – Mix your paints on a piece of glass. You may wish to tape the edges for safety.

Palette – I like to use a "stay-wet" type of palette. I prefer a palette that stays wet because acrylics dry so quickly. A wet palette consists of a plastic tray that holds a wet sponge and special paper. Wet palettes can be found wherever decorative painting supplies are sold.

Water Basin – Use a water basin or other container filled with water for rinsing your brushes.

100% Cotton Rags Use only 100% cotton rags for wiping your brush. You could also use soft, absorbent **paper towels** for wiping brushes. *How soft? Try the knuckle test: For 15 seconds, rub your knuckles on the rag. If your knuckles bleed, think what that rag will do to the hairs of your brushes!*

Toothbrush – Use an old or new toothbrush for flyspecking.

Masking Tape – Use an easily removable, low-tack masking tape to secure tracing paper to the surface when transferring a design, as well as for masking areas you do not want painted.

Varnish – Use a varnish especially for acrylics or a damar (resin-based) varnish to add a final coat to your painting.

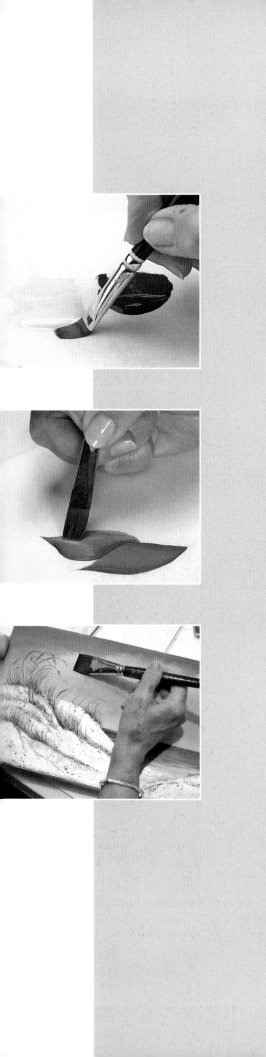

General Information

This could be called the "How to" chapter. It has that kind of practical information: how to prepare the canvas, how to transfer the pattern to the surface, how to load and use the different kinds of brushes. You get the idea!

Like every skill, painting has a vocabulary of its own, and the terms and techniques call for specific actions. Review the "Painting Techniques" section before you begin a project, because the project instructions are written in this painter's language. You may be instructed to mix a wash, float shading, or undercoat a design element. This section not only defines the terms, it also includes photos that show you the techniques.

If you are new to painting, it is a good idea to practice the brush loading and stroking techniques until they are comfortable for you. If you practice before you begin a project, you can focus your attention on your painting rather than on the mechanical aspects of handling the brush and paint. It's simply more fun!

Preparing the Canvas

Pre-Primed Canvas

To prepare a pre-primed canvas, sand the surface lightly with fine grade sandpaper. Wipe off all traces of sanding dust with a tack cloth before painting.

Unprimed Canvas

Brush on at least two coats of white acrylic gesso. Let dry and sand lightly after each coat. Remove all traces of sanding dust with a tack cloth before you begin your painting.

Transferring Patterns

It is fine to transfer designs to the canvas with white or gray transfer paper; however, this is my least favorite way to transfer a design because transfer paper tends to smudge. Chalk is my favorite; the pattern lines are easily removed and the chalk dissolves as you paint over it. When you trace a pattern, it is not necessary to trace the shading lines or the fine details.

Transferring a Design with Transfer Paper

1. Trace the pattern neatly and carefully from the book onto tracing paper, using a pencil or a fine point marker.
2. Position the tracing on the canvas and secure it with masking tape.
3. Slide the transfer paper under the tracing with the transfer side facing the canvas.
4. Using a stylus, neatly trace over the pattern lines to transfer the lines to the canvas.

Transferring a Design with a Charcoal Pencil

1. Neatly trace the pattern onto tracing paper, using a pencil or a fine point marker.
2. Turn over the traced design. Firmly go over the traced lines on the back with a charcoal pencil. (Photo 1) Do not scribble all over the back of the tracing paper.
3. Position the traced design on the canvas, charcoal side down. Secure it in place with masking tape. Using a stylus, go over the pattern lines. (Photo 2) The pattern lines will be transferred to the canvas.

Transferring a Design with Chalk

1. Neatly trace the pattern onto tracing paper, using a pencil or a fine point marker.
2. Turn over the traced design. Firmly go over the traced lines on the back with chalk. (Photo 3) Do not scribble all over the back of the tracing paper. Shake off the excess chalk dust, being careful not to inhale the particles.
3. Position the traced design on the canvas, chalk side down. Secure it in place with masking tape. Using a stylus, go over the pattern lines. (Photo 4) The pattern lines will be transferred to the canvas.

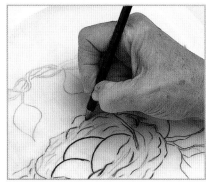

Photo 1

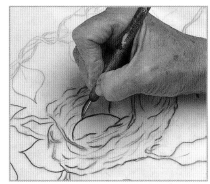

Photo 2

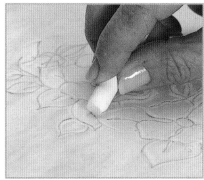

Photo 3

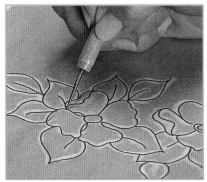

Photo 4

Brush Use

DOUBLE LOADING A FLAT BRUSH

Double-loading means loading your brush with two colors of paint. Mix the two puddles of paint on your palette, thinning the paint with glazing medium or water to a flowing consistency. Push each puddle with the palette knife into a neat shape with clean edges.

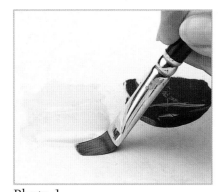

Photo 1

Stroke up against the edge of the light color 30 times, so half of the brush is loaded with paint and the other half is clean.

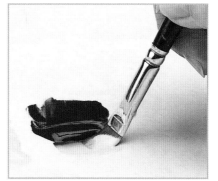

Photo 2

Turn the brush over and stroke up against the edge of the dark color 20 times.

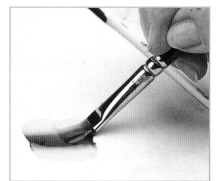

Photo 3

Blend, blend, blend one side of the brush on your palette. Turn the brush over and blend, blend, blend on the other side, keeping the dark color in the center and the light color to the outside. Pick up more light paint on the brush and blend some more. Pick up more of the dark color and blend some more. Continue doing this until your brush is really full with paint. You don't want a space between the two colors; you want them to blend into each other in the center of the brush.

USING A FAN BRUSH

A fan brush is used to paint wispy lines, such as painting grass. When loading the fan brush, have your paint a little less thick by mixing it with Floating Medium or water. Pull the paint away from the paint puddle with the bristles of the brush. Load both sides of the brush in this manner.

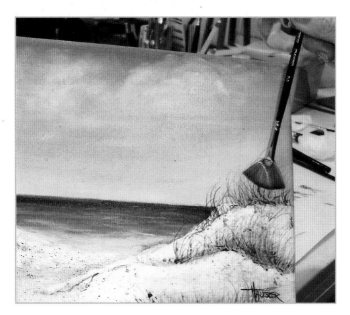

OUTLINING AND DETAIL WORK WITH A LINER BRUSH

Liner brushes are used to paint lines and details in every project in this book. For the greatest control and best results, fill the brush full of thinned paint so it will flow freely from the tip of the liner.

Photo 1
Thin the paint with water until it is the consistency of ink.

Photo 3
To use the liner, stand the brush on its point with the handle pointing straight up toward the ceiling. Move the liner slowly to produce fine lines.

Photo 2
Fill the brush full of paint by pulling it through the edge of the paint puddle. Twist the brush as you pull it out of the paint puddle; this will form a nice pointed tip.

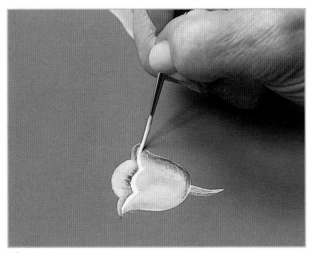

Photo 4
Using a liner brush to outline the edge of a flower petal with thinned Titanium White.

Painting Techniques

COLOR BOOK PAINTING

"Color book painting" means to fill in solidly with one color just as you would color in a coloring book. This blocks in the basic color and shape of a design element; shading and highlighting will be applied on top of the basic color. This may also be referred to as "undercoating" or "blocking."

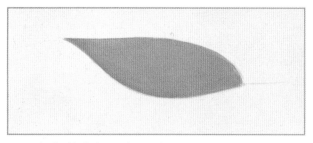

Here a leaf is blocked in with a medium gray-green. Shading and highlighting will be applied on top of the solid color.

WASH

A wash is a transparent application of very thin paint. You could say it is water with just a little color in it that is applied over a painted surface to add a blush of the color. When you are using acrylics, paints may be thinned with water or a medium such as glazing medium or floating medium. In this photo, a very thin gray/purple color is washed over the sky area.

OUTLINE

Outlining is generally done with the liner brush and thin paint, and simply means to paint a line around an object you have painted. When outlining, the liner brush should be good and full of paint that has been thinned to the consistency of ink.

SHADING & HIGHLIGHTING BY "FLOATING"

Highlighting is often, but not always, applied as you are finishing a painting to show where light falls on an object. Shading is the combination of two or more colors to create contrast and dimension.

Floating is flowing color on a surface. This technique is used for adding the shading and highlighting to design elements. Before floating, block in the area with the medium tone color of the design element (*color book painting*). Let dry. The example shows shading and highlighting floated on a leaf that has been solidly painted with a medium gray-green color. *See photos 1-8.*

Photo 1
Fill your brush with floating medium. The brush size is determined by the design.

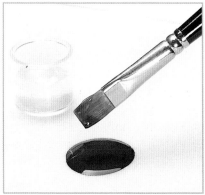

Photo 2

Fill one side of the brush with the shading color by stroking up against the edge of a puddle of paint.

Photo 3

On a matte surface, such as tracing paper or wet palette paper, blend, blend, blend on one side of the brush.

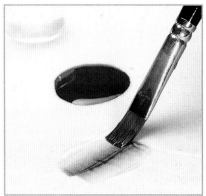

Photo 4

Turn the brush over and blend, blend, blend on the other side. Keep the paint in the center. Be sure the brush is good and full of paint and that the color graduates through the brush from dark to medium to clear.

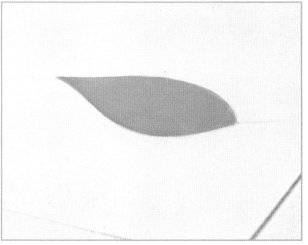

Photo 5

Shading and highlighting will be floated on top of the dried color book painting. This leaf was undercoated with a medium gray-green.

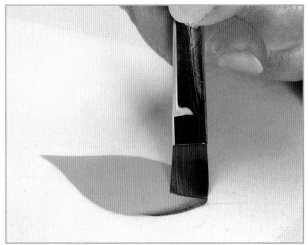

Photo 6

Float on the shading at the edge of the design element (here, a leaf), with the dark side of the brush toward the outside of the design. Let dry. Repeat, if desired, to deepen the color.

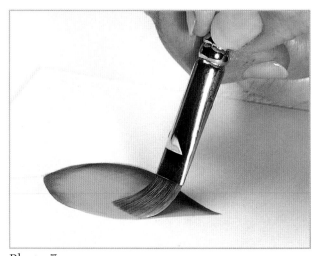

Photo 7

Float highlighting on the opposite side of the design, using the same technique as shading but using a light color.

Photo 8

You can use water in place of floating medium. Dip the brush in water and blot it by pulling the brush gently along the edge of the water basin. Load the brush with paint and blend it on the palette.

Painting Techniques, continued from page 19

BLENDING

Blending means to move two or more colors together to create shading and show dimension. Blending medium, which allows you to easily blend colors together, is painted onto the design area you want to blend. First, block in the shape and allow the undercoat to dry.

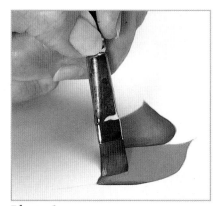

Photo 1
Float on the shading and highlighting. Let dry.

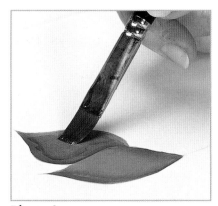

Photo 2
Add a small amount of blending medium to the area of the design where you will be blending color.

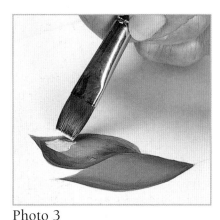

Photo 3
Add the colors you wish to blend on top of the wet medium.

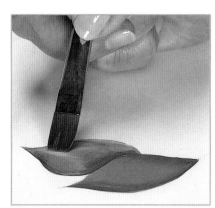

Photo 4
Lightly blend or move the colors together, using an extremely light touch. If you are heavy-handed, you will wipe all the color away. If this happens, let the blending medium dry and cure and begin again or remove the color before it dries, add more blending medium, and begin again.

DABBING

Sometimes you will want to apply colors lightly and irregularly. After all, not everything in a landscape is smoothly blended. Pick up some paint on your brush and apply the paint lightly to the surface with an up-and-down motion; you may feel a little "bounce" on a tightly stretched canvas. Apply the paint in multiple, unaligned touches, rather than long strokes. You do not need to clean your brush thoroughly between colors. Just wipe it on a soft rag or paper towel, pick up the next color, and dab it on the canvas.

FLYSPECKING

Spattered flyspecking may add texture and interest to your painting. It is also a good and quick way to add the illusion of falling snow to your landscape painting. You will need an old toothbrush, the paint color of your choice, glazing medium, a palette knife, and a mixing surface such as a palette or a plastic container.

1. Place a small amount of the paint on the mixing surface. Add glazing medium to the paint and mix with a palette knife to a very thin consistency. The thinner the paint, the finer the spatters. Thicker paint makes larger spatters.
2. Dip the toothbrush bristles in the thinned paint. (Photo 1)
3. Holding the bristles down, point the toothbrush at the surface and pull your thumb across the bristles to spatter paint over the surface. (Photo 2) You may pull the palette knife across the bristles instead of your thumb.

Photo 1
Loading the toothbrush with thinned paint.

Photo 2
Flyspecking the surface.

FINISHING YOUR PAINTING

Your painted pieces need to be protected from dust, dirt, wear and tear. Even if the canvas is hanging on the wall, dust will still settle on it. Coating it with a finish will protect the paint and allow you to wipe off the dust without harming the surface of the painting.

Allow the paint to dry and cure. Brush on one or more coats of damar varnish or a varnish made especially for acrylics. Apply the varnish with a soft bristle brush and allow the varnish to dry between coats.

PAINTING TIPS

• When loading a brush with a different color, but one that is in the same color family, it is preferable to wipe the brush on a damp paper towel to remove excess paint before loading the new color. Avoid rinsing the brush too often in water.

• When loading your brush with a color in a different color family, the brush does not need to be thoroughly cleaned. Simply rinse it in water and blot the brush on a paper towel to remove excess water. Load the brush with a new color.

• Sometimes I paint with a "dirty brush." Leaving some of the color from another element in the brush seems to blend the colors together better. For example, if I want to add a reddish tint to a leaf, I will leave a little green in my brush when I load the red so the colors can "marry."

Tips for Painting a Landscape

BEGIN WITH THE SKY
Draw the horizon line of the painting using a very light pencil line. Paint in the sky, bringing the sky slightly below the horizon line.

PAINT THE GROUND
Start with the elements that are farthest from you and gradually come forward. For instance, paint mountains, then the distant trees and distant ground, then maybe a building or a tree in the middle ground, and last, the foreground elements.

ADDING SHADE OR HIGHLIGHT
Shading and highlighting depend on the time of day and where the sun or light source is coming from. The type of sky (winter, summer, fall) will determine where the highlights will be.

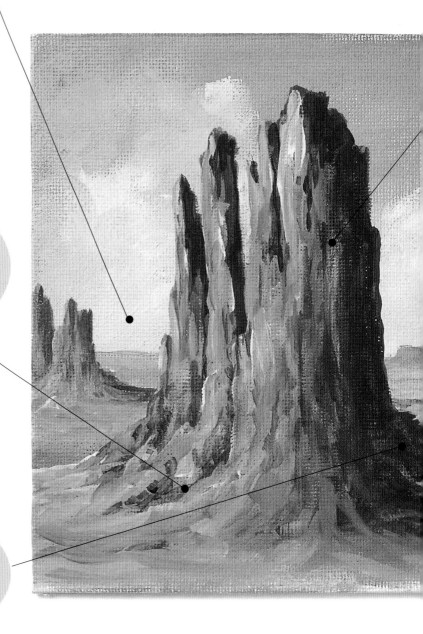

COLOR VALUES

The things in the very far distance are lighter in value, those in the middle part of a painting are the medium values of colors, and those in the foreground are more intense and darker.

PROPORTION

• The items in the foreground are much bigger than those in the middle area or the distance.
• The items in the foreground of the painting will have more detail than those in the middle distance.

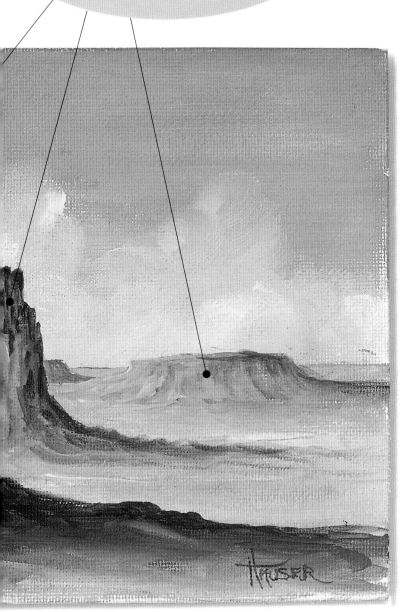

OBSERVE

One of the best ways to understand these concepts is to find a spot you would like to paint, sit and observe it at different times of the day. Watch the shadows. Take photos and work from them. I like black and white photos because they really show the dark, medium, and light values in a composition, but color will do! Make sketches, even rough ones, with notes about highlights and dark areas and how colors may change as the sunlight moves.

PAINT IN STAGES

Each of the miniature landscapes in this book has painting worksheets that show you how to develop the painting in stages. Look closely at the worksheets as you read the instructions and you will find it is easy to paint a complex scene when you do it in these four stages:
Stage 1: Paint the sky and background;
Stage 2: Block in all the elements;
Stage 3: Add details;
Stage 4: Refine the details and adjust highlights and shading.

Painting Landscape Elements

The very first note in this section tells you: "Skies are always darker at the top and lighter toward the horizon." Right away, you have learned one of the rules that give artists' landscape paintings their natural appearance. And there are many more to come: tips for painting clouds, trees, waterfalls, and desert rocks; step-by-step instructions for painting shadows on a sandy beach or under an overhanging roof; directions for mixing colors to use for foliage in spring, summer, fall or winter.

Perhaps the most inescapable feature of the natural world is the weather. It determines the quality of the light, the color and coverage of foliage, and the reflective properties of smooth or choppy water surfaces. The same acre of land looks quite different in different seasons, so these instructions equip you with the knowledge you need to make that difference with your paint.

This reference section is useful when you are painting the projects in this book, but it is most valuable when you design landscape paintings of your own. You will turn to it again and again for practical advice on transforming a beautiful view in three dimensions into a successful painting in two dimensions . . . and have fun doing it.

Painting Skies

- Skies are always darker at the top and lighter toward the horizon.

- The horizon line is always below or above the center of the canvas; for example: two thirds sky and one third ground, or one third sky and two thirds ground. (There is an exception to this rule. Canyon scenes have unusual and dramatic viewpoints.)

- A winter sky will be more grayed than a bright fall or summer sky. Gray the sky by adding just a touch of Pure Orange or Burnt Umber to the Sky Mix.

- Standard Sky Mixture: one part Prussian Blue + three or four parts Warm White (1:3 or 1:4). This blue is used on skies and water.

Standard Sky Mix

SUMMER SKY

1. Mix the Sky Mix, using one part Prussian Blue + four parts Warm White (1:4).
2. Start at the top of the canvas and paint across horizontally from side to side.
3. As you come down the sky, pick up some Warm White on the uncleaned brush and again, paint across the canvas.
4. Repeat, picking up more Warm White as you go, until the sky is lighter at the bottom. You may wipe paint from the brush if it gets too thick, but do not wash the brush.

SUMMER SKY WITH CLOUDS

1. Paint a standard Summer Sky.
2. Clean the brush. Pick up some Warm White and swirl it on the canvas while the sky is wet. Wipe the brush.
3. Pick up more Warm White and make another, lighter group of clouds behind the first group.

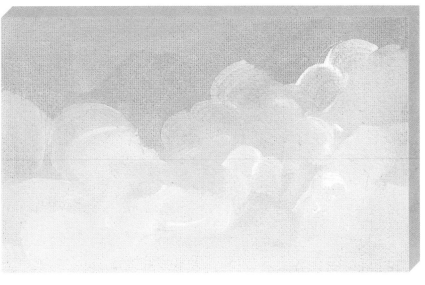

GRADED WINTER OR SUMMER SKY

1. Place the darker color at the top third of the sky.
2. Paint Warm White on the lower third of the sky.
3. Pull the Warm White into the dark color, wipe the brush, and pull the dark color into the Warm White. Wipe the brush.
4. While the paint is wet, pull a clean, damp brush across the blended areas to soften the transition between colors. Wipe the brush after each stroke.

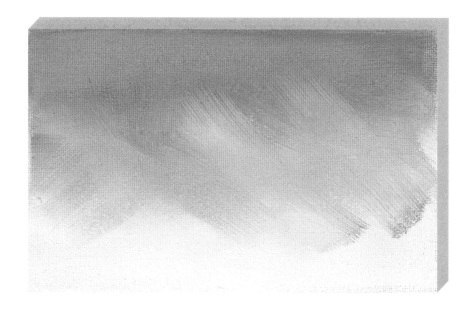

STORMY SUMMER SKY

1. Paint a standard Summer Sky.
2. While the paint is wet, swirl in the first set of clouds with Warm White.
3. While the paint is still wet, swirl in the second group of clouds with the Sky Mix.
4. While the rest of the sky is still wet, swirl in the final group of clouds with Warm White.

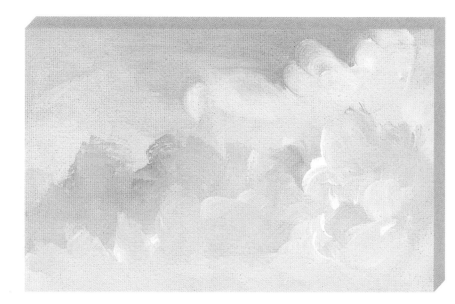

STORMY WINTER SKY (GRADED)

1. Add a touch of Burnt Umber and a touch of True Burgundy to the Sky Mix. Darken the mixture with Prussian Blue if desired.
2. This is a graded sky, so paint the upper part with the Dark Sky Mix and the lower part with Warm White.
3. While the paint is wet, pull the Warm White into the Dark Sky Mix, wipe the brush, and pull the Dark Sky Mix into the Warm White. Continue to blend, wiping the brush after each stroke. Leave the top much darker.

SUNSET/SUNRISE SKY: PLATE I

1. Mix one part Prussian Blue + four or five parts Warm White (1:4 or 1:5).
2. Mix one part Yellow Medium + four parts Warm White (1:4).
3. Apply the light blue mix to the canvas at an angle.
4. While the paint is wet, paint streaks of the yellow mix at the same angle.
5. While the paint is wet, and with the yellow mix in the brush, pick up a touch of Pure Orange. Streak at the same angle at the bottom of the sky.

SUNSET/SUNRISE SKY: PLATE II

1. Clean the brush and blot out excess moisture. Softly blend the yellow into the blue, pulling the brush at the same angle as the paint was applied. Wipe the brush after each stroke.
2. Clean and blot the brush. Blend the orange into the yellow, using the same method.

SNOWY SKY (GRADED)

1. Add a touch of Asphaltum or Burnt Umber to darken the Sky Mix.
2. This is a graded sky, so paint the upper part with the Dark Sky Mix and the lower part with Warm White.
3. While the paint is wet, pull the Warm White into the Dark Sky Mix, wipe the brush, and pull the Dark Sky Mix into the Warm White. Continue to blend, wiping the brush after each stroke. Leave the top much darker.

Painting the Ground

- Mountains in the distance are more intense in color at the top and lighten toward the base.

- Mountains are not uniform in height.

- Mountains are not perfectly symmetrical; they have a right and a left side.

- Where mountains touch the horizon, there is a haze that can be painted, transitioning into the ground colors.

- Always use the sky colors at the base of mountains, where they meet the ground.

- The ground is always lighter in the distance and becomes darker in value as you paint toward the foreground.

- The best ground/grass colors are:
 Yellow Ochre + Hauser Green Medium
 Yellow Ochre + Burnt Umber + Hauser Green Medium
 Yellow Ochre + Warm White
 Yellow Ochre + Hauser Green Medium + Warm White
 Yellow Ochre + Prussian Blue

DISTANT HILLS/MOUNTAINS: PLATE I

1. Add a touch of Alizarin Crimson to the Sky Mix. (See "Painting Skies")
2. Paint the mountain shape.

DISTANT HILLS/MOUNTAINS: PLATE II

1. Add a little more Prussian Blue to the mountain color. Pull this darker color down the shadow side in the direction the mountain slopes.
2. Highlight with Warm White and the mountain color.

FIELD WITH GRASS: PLATE I

1. Mix one part Yellow Ochre + four parts Warm White (1:4).
2. Pick up on your brush a little Yellow Ochre Mix and a little Sky Mix.
3. Paint these colors along the horizon line.
4. To create darker values, pick up a little more Sky Mix and a touch of Yellow Ochre. Pat and dab in the middle ground and foreground area. Do not blend.

FIELD WITH GRASS: PLATE II

1. Load a liner brush with thinned Yellow Ochre. Pull strokes upward and curve to the right to create distant grass.
2. Pick up a little Prussian Blue and more Yellow Ochre Mix and pull more grass strokes in the middle ground area.
3. Mix one part Prussian Blue + one part Burnt Umber (1:1). Load the liner brush and pull grass strokes in the foreground. The grass in the foreground is darker and a little taller.

OCEAN/SAND/BEACH

Sand is lighter in the distance and darker in the foreground.

1. Mix one part Yellow Ochre + four parts Warm White (1:4). Paint the sand area.
2. While the paint is wet, pick up some Yellow Ochre and pat it into the middle area and toward the edges.
3. Shade the sand by picking up the Yellow Ochre Mix and Burnt Umber on the brush and patting onto the canvas.

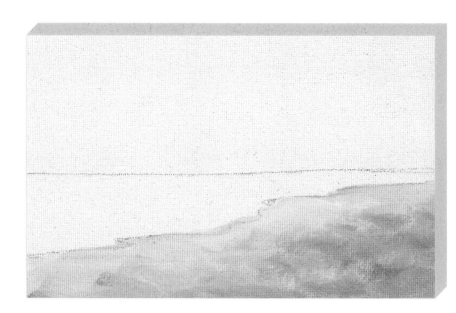

DIRT ROAD: PLATE I

Roads are always darker in the distance and lighter in the foreground.

1. Apply Burnt Umber at the farthest point and pull the paint along the road toward the foreground.
2. Pull a little Warm White into the Burnt Umber to lighten the road in the foreground.
3. Continue to pull the brush with the Warm White into the Burnt Umber as if you were following the ruts into the distance.

DIRT ROAD: PLATE II

1. While the paint is wet, pull some more Burnt Umber streaks forward to darken the ruts.
2. Wipe the brush. Pick up some Warm White and a touch of Burnt Umber and pull ruts closer to the foreground area of the road.

ROAD IN SNOW: PLATE I

1. Paint the road with Warm White. Do not clean the brush.

2. While the paint is wet, pick up just a little Sky Mix and pull from the back of the road forward. It should look like tracks in the snow.

ROAD IN SNOW: PLATE II

1. While the paint is wet, pick up some Sky Mix plus Burnt Umber on the brush. Pull strokes to look like ruts or tracks in the snow.

2. Shade the snow with the Sky Mix on the snow bank on the left side of the road.

3. Shade a little on the snow bank on the right side of the road.

SNOW: PLATE I

1. Paint distant snow with the Sky Mix (see "Painting Skies" on page 25 for mix ratio) and Warm White. The distant snow is darker than the snow in the foreground.
2. Paint the foreground snow with Warm White.

SNOW: PLATE II

While the paint is wet, use a touch of Sky Mix on the brush to add shadows. Shadows have a definite edge, then are blended outwards.

HINT: Take some photos of nothing but snow and shadows to help you define these elements.

ROCKS ON DRY LAND: PLATE I

Rocks are very blocky in shape.
1. Undercoat the rocks with a wash of Yellow Ochre.
2. While the paint is wet, pull in Burnt Umber with a flat brush on the right side. It should be uneven in texture.

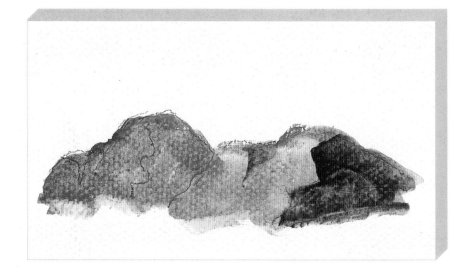

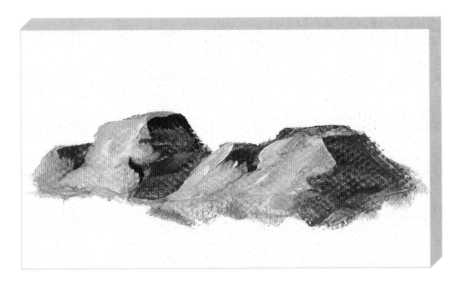

ROCKS ON DRY LAND: PLATE II

1. Pick up some Yellow Ochre and some Warm White. Lightly stroke on the left sides of the rock formations to highlight.
2. Deepen the shading on the dark side with Burnt Umber if needed.

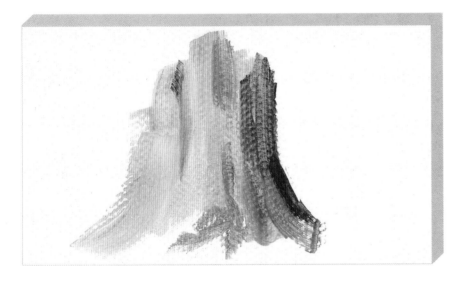

ROCKS IN THE DESERT: PLATE I

1. Paint in the shape with a wash of Yellow Ochre.
2. While the paint is wet, brush some Burnt Umber on the shadow side. Follow the shape by pulling the stroke down and curving outward at the base. Let dry.

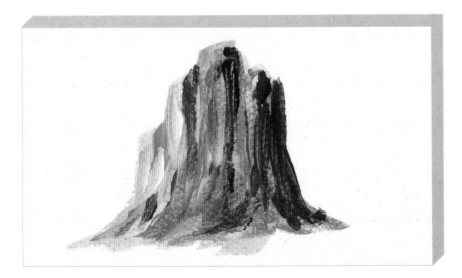

ROCKS IN THE DESERT: PLATE II

Do not blend the colors. They will blend roughly as you pull strokes wet on wet.

1. Brush on a little Burnt Sienna, again pulling the strokes down and curving outward.
2. Darken the shading with Burnt Umber.
3. Mix one part Yellow Ochre + one part Warm White (1:1). Highlight the rocks.

Painting Water

• Water is always light in the distance and gets darker as you paint toward the foreground. Looking at photos of bodies of water will help you see this.

• Water can reflect the sky as well as the things on the banks.

• Water works like a mirror.

• Use short horizontal strokes to paint water.

WATERFALL: PLATE I

1. Mix one part Sky Mix (See "Painting Skies") + one part Warm White (1:1). Paint the upper part of the waterfall.
2. Mix one part Sky Mix + one part Prussian Blue (1:1). Paint the lower part of the waterfall.
3. Wipe the brush. Begin pulling the two colors into each other. Wipe the brush after every one or two pulls.

WATERFALL: PLATE II

1. Pull strokes of Warm White from the top of the falls downward.
2. Thin a mixture of one part Sky Mix + one part Prussian Blue (1:1). Pull darker strokes upward from the base of the waterfall.
3. Apply a hint of Burnt Umber wash over the darker part of the base of the waterfall.
4. Stroke Warm White highlights downward from the top of the waterfall.

OCEAN: PLATE I

1. Paint the area of the ocean with Sky Mix.
2. Add a touch of Prussian Blue to some Sky Mix. While the ocean paint is
 wet, darken the foreground area. Let dry.
3. Use the darker color to add short horizontal strokes in the ocean area.

OCEAN: PLATE II

1. Using the chisel edge of a ½" flat brush, paint horizontal strokes with
 the Sky Mix + Prussian Blue mixture to create darker waves.
2. Highlight with Warm White to make whitecaps.

Water is *always* lighter in the distance and darker in the foreground. Take
some water photos and look at them.

CREEK: PLATE I

1. Paint the area of the creek with Sky Mix.
2. Add a touch of Burnt Umber to some Sky Mix. Blend into the foreground area of the creek.
3. Pull horizontal strokes across the water with one part Sky Mix + a touch of Burnt Umber (1:touch), and with one part Sky Mix + a touch of Prussian Blue (1:touch).

CREEK: PLATE II

1. To intensify the colors, add more Prussian Blue to the Prussian Blue + Sky Mix, and more Burnt Umber to the Burnt Umber + Sky Mix. Paint more horizontal strokes to indicate shadows and reflections.
2. Highlight the center of the water with Warm White and Sky Mix.

Water is *always* lighter in the distance and darker in the foreground.

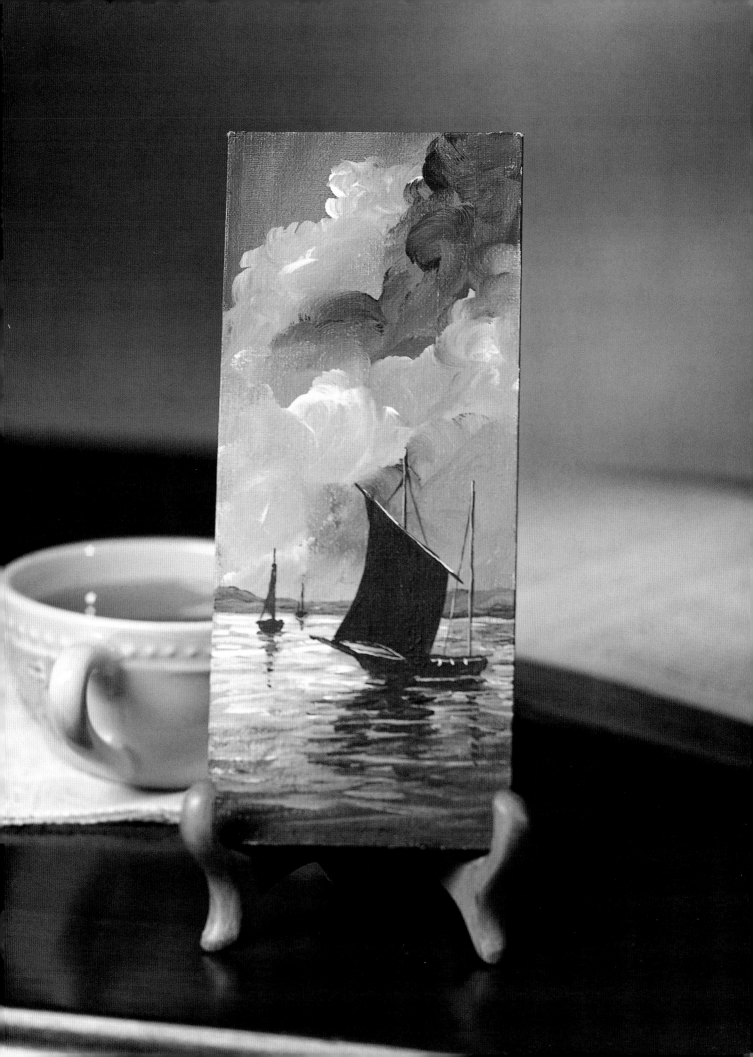

Painting Trees

- Distant trees are not detailed. Their colors are more muted or blended.

- Paint foliage on spring trees with more yellow greens.

- Paint foliage on summer trees with more blue tones.

- Fall trees are best done with muted yellows, oranges, and Alizarin Crimson.

- Paint cedar trees with more olive greens.

- Pines have more blue/green tones.

- The silhouette of a leafless tree takes on an imaginary leaf shape.

- Always use the Sky Mix in the trees and ground areas to keep all the colors compatible with each other.

BASIC TREE TRUNK SHAPE: PLATE I

1. Main tree trunks are larger at the base and thinner at the very top.
2. Main branches pull off the trunk and lift outward and upward. They are thinner toward their tips.
3. Tree trunks and branches should be loose, not straight and stiff.

BASIC TREE TRUNK SHAPE: PLATE II

1. Smaller branches pull off each branch in the same manner as the large branches come off the trunk.
2. It may be easier to tip the canvas sideways to achieve this branching effect.

BASIC TREE TRUNK SHAPE: PLATE III

1. Continue pulling smaller branches.
2. Remember that each level of branches is shorter and thinner.
3. The outer, dashed line around the trunk and branch area is the shape of the tree with leaves.

LEAF SHAPE

1. Look at a leaf and notice the veins. They form the same shape as the tree trunk and branches.
2. The leaf will echo the shape of the tree with full foliage. (This applies to a tree whose shape has not been altered by wind or weather damage.)

DISTANT BARE TREES

1. These are done in the same manner as the basic tree trunks and branches, but are a little more wispy, like willows.
2. Some branches are just lines pulled upward.

PINE TREES WITH SNOW: PLATE I

1. Draw the shape.
2. Using slightly thinned, dark Olive Green, pull pine needle strokes on the lower sides of the branches. Leave the upper parts of the branches free of paint. The snow will be painted there.

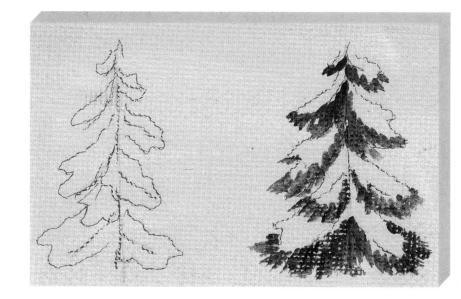

PINE TREES WITH SNOW: PLATE II

1. Add a tiny touch of Prussian Blue to the Olive Green. Darken the branches toward the center of the tree. Let dry.
2. When dry, apply Warm White to the tops of the branches.
3. Shade the snow with a mixture of one part Warm White + a touch of Prussian Blue + a touch of Burnt Umber (1:touch:touch). Pat this on the lower, shadow part of the branches and on the snow below the tree.

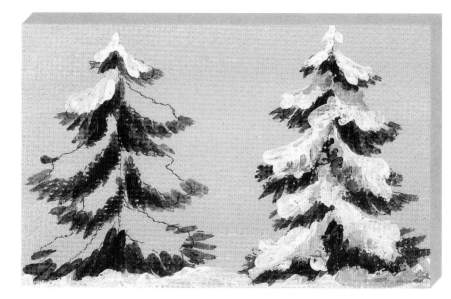

TREE BARK: PLATE I

1. Wash a thin mix of Yellow Ochre and water onto the tree trunk.
2. While the paint is wet, pull thinned Burnt Umber on the right side of the trunk and the major branches.
3. Pull the two colors into each other at an angle, but do not blend.

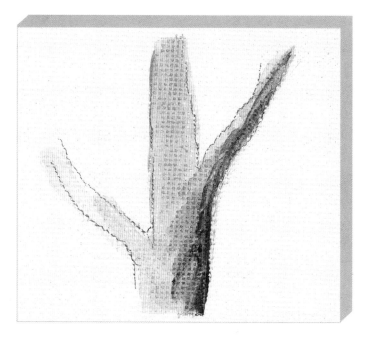

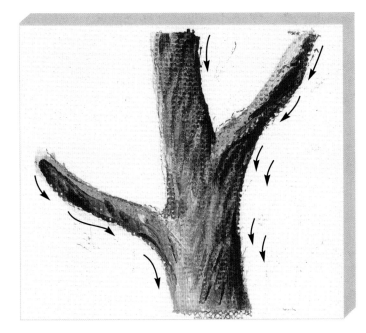

TREE BARK: PLATE II

1. While the paint is semi-wet, pick up some more Burnt Umber. Pull at an angle onto the trunk in short strokes.
2. Highlight the left side of the trunk and the major branches with short strokes of Yellow Ochre and Warm White.
3. To maintain the textured effect, do not blend.

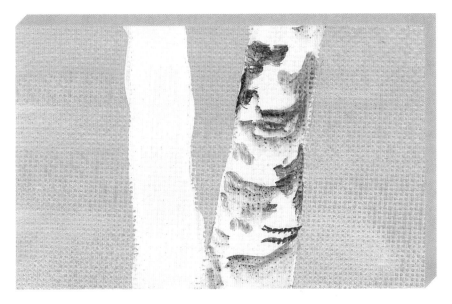

BIRCH TREES: PLATE I

1. Paint the trunk with two coats of Warm White.
2. While the paint is semi-wet, pull some thinned Pure Black strokes and marks horizontally across the trunk, pulling from both sides toward the center.

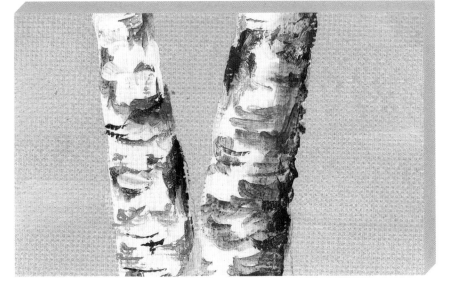

BIRCH TREES: PLATE II

1. Darken spots and marks in the bark with more Pure Black.
2. Allow the trunks to dry completely. Mix a wash of Prussian Blue + a touch of Pure Black. Pull the wash down the dark side of the trunk to create shadows.

DISTANT TREES IN SNOW: PLATE I

1. Paint the tree area by patting on a touch of Burnt Umber with Warm White in your brush.
2. Pat on a little more Burnt Umber at the base of the trees. Let dry.

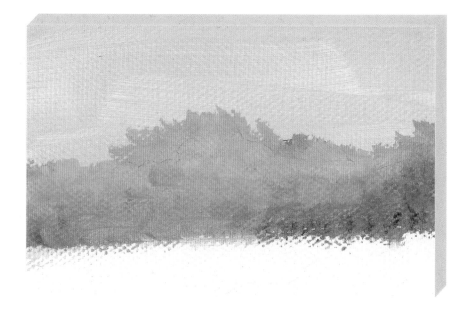

DISTANT TREES IN SNOW: PLATE II

1. Pat on a light amount of Warm White at the tops of the trees. Blend into the base color with small patting strokes.
2. Detail the dark trunks by pulling thinned Burnt Umber lines upward from the ground with the liner.
3. Pull the lines for the light trunks with thinned Warm White.

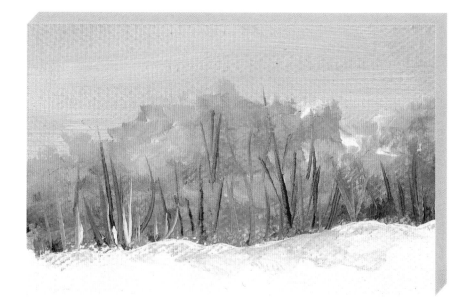

DISTANT SUMMER TREES: PLATE I

1. Paint the tree area with Hauser Green Medium.
2. While the paint is wet, pat Yellow Medium onto the tops and the sides toward the light. Soften by patting into the Hauser Green Medium.

DISTANT SUMMER TREES: PLATE II

1. Shade the lower part of the trees by patting on a mixture of one part Hauser Green Medium + a touch of Prussian Blue (1:touch)
2. Pat a small amount of Burnt Umber along the ground line.
3. Highlight the tops of the trees with a mixture of one part Yellow Ochre + two parts Warm White (1:2).

DISTANT SPRING TREES

1. Paint the tree area with a mixture of one part Sky Mix + one part Yellow Medium (1:1).
2. While the paint is wet, shade by patting on a little more Sky Mix and a tiny touch of Prussian Blue.
3. Do not clean the brush. Pick up a touch of Pure Orange and pat into the tree area.
4. Highlight the light edges and tops of the trees with a mixture of one part Yellow Medium + one part Warm White (1:1).
5. Darken the base with more Sky Mix and Prussian Blue if needed.

Painting Grasses

GRASS IN BEACH SAND: PLATE I

1. The sand has been painted with a mixture of one part Yellow Ochre + four parts Warm White (1:4).
2. Use a small fan brush or a thin liner to pull strokes upward with thinned Olive Green and the Sky Mix.
3. Make darker strokes using paint that has not been thinned.

GRASS IN BEACH SAND: PLATE II

1. Use a liner to pull strokes of Olive Green and Yellow Ochre upward to make the Sea Oats.
2. Paint shadows with a thinned mixture of one part Sky Mix + a touch of Prussian Blue (1:touch).

GRASS IN SNOW

After the snow and shadows have been painted, paint the grass with a liner brush.

1. Pick up some thinned Yellow Ochre and pull upward and to the right.
2. Space the grass stems apart from each other so they will appear to be covered with snow at their bases.
3. Paint some grasses with thinned Burnt Umber.
4. Paint the shadows with a thinned mixture of one part Prussian Blue + one part Burnt Umber (1:1).

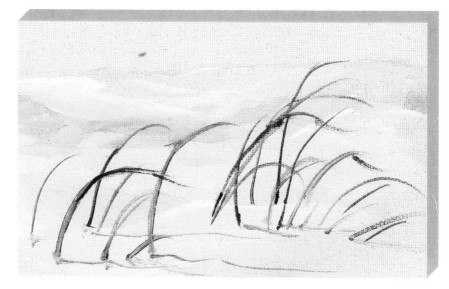

Painting Buildings & Other Objects

Wooden Buildings and Other Objects

- Paint the wood on buildings, fence posts, etc. using earth tones.
- To achieve a weathered or painted look for wooden buildings or objects, allow the painting to dry, then stain over the wood areas with a wash of Burnt Umber.
- To achieve the effect of boards, apply the paint thickly, then pull lines through the wet paint with a toothpick.

Shadows

- Paint the shadows with thinned Prussian Blue or a mixture of Prussian Blue + Warm White + a touch of Burnt Umber.
- Thin shadow colors to the consistency of tea.

Shadows on Buildings

- Buildings and objects will generally have one light source.
- The building or object will have a light area (closest to the light), a medium area (2nd from the light source) and a dark area (farthest from the light source).
- When in doubt about a shadow, take a flashlight, find a small box or toy the shape of the object in question, and go into a dark room or closet. Shine the light on the object. Move the light and watch the shadow move.
- Look at black and white photos, noticing the dark, medium, and light areas.

Shapes & Brush Strokes on Objects

ROOFS

When you are painting a roof, the brush strokes should be at an angle as if the brush were sliding down the roof.

VERTICAL SHAPES

When you paint the sides of buildings or objects that are vertical, the strokes will be up and down.

ROUND OBJECTS

When you paint a round object, the brush strokes will follow the shape of the object.

FENCE POSTS

1. Paint the post with Yellow Ochre.
2. Paint Burnt Umber on the shadow side (right side).
3. While the paint is wet, pull the Burnt Umber down in short, angled strokes to create texture.
4. Darken the post with more Burnt Umber.
5. Highlight the post with a mixture of one part Yellow Ochre + three parts Warm White (1:3).

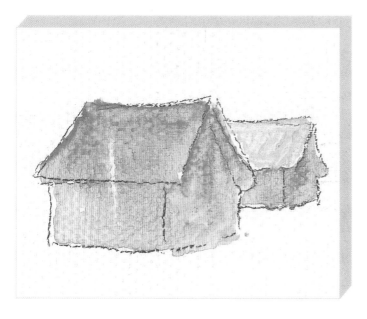

BUILDINGS: PLATE I

1. Paint the roof and sides of the shingled roof building with thinned Yellow Ochre.
2. Paint the sides of the tin roofed building with thinned Yellow Ochre.
3. Paint the tin roof with the Sky Mix. Let dry.

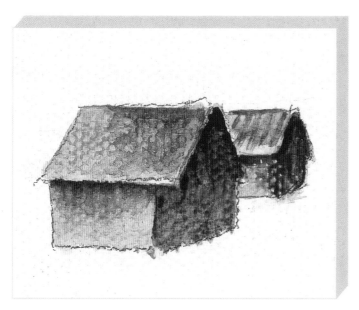

BUILDINGS: PLATE II

1. Paint the dark sides of the buildings with Burnt Umber, not too thick.
2. Blend Burnt Umber under the roof overhang on the light side.
3. On the shingled roof, blend a Burnt Umber wash on the top and the right edge of the roof. Pat the wash on.
4. On the tin roof, pull Burnt Umber streaks down the slope of the roof.

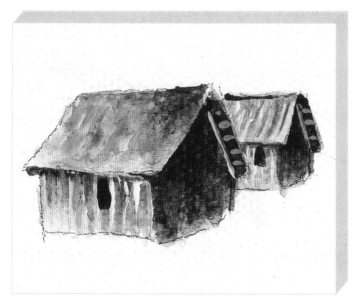

BUILDINGS: PLATE III

1. Mix one part Yellow Ochre + one part Warm White (1:1). With the liner, apply vertical lines to indicate boards.
2. Paint a Burnt Umber line under the roof on the light side of both buildings.
3. Paint the eave overhang on the dark side of both buildings with Burnt Umber.
4. Detail the boards on the overhang with Yellow Ochre.
5. Paint the windows with Burnt Umber.
6. Highlight the light side of the shingled roof with a mixture of one part Yellow Ochre + one part Warm White (1:1). Pat on like shingles.

Landscape Paintings

These Minis put all the landscape elements to work in delightful little canvases that are perfect for decorating your own home or giving to friends and family. The instructions are divided into stages, and each stage has its own painting worksheet for easy reference. Preparing a primed canvas is quick and easy; simply sand it lightly and remove all traces of sanding dust. You are ready to paint.

Mixing colors is a necessary part of painting. It is hard to get exactly the same result every time you mix paints. Following the proportions will help, but looking at the swatches provided at the beginning of the instructions will be a better guide.

Don't be afraid to mix color. Go for it! Once you have tried it, you're going to like it. Don't worry about matching the color swatch too precisely; you will probably mix a color you like better. Working with a dirty brush and selecting darker or lighter shades will help your colors make a more gradual, harmonious change on the canvas.

These general supplies are not listed with the individual project instructions, but you will need to have them on hand for every painting session.

Fine grade sandpaper for preparing the canvas
Tack rag for removing sanding dust
Tracing paper for tracing patterns
Transfer paper for transferring designs to the canvas
Stylus for transferring designs to the canvas
Palette knife for mixing and moving paint
Glass surface for mixing paints
Palette for setting out paints
Water basin for rinsing brushes
Cotton rags or soft, absorbent *paper towels* for wiping brushes
Toothbrush for flyspecking
Masking tape for securing tracing paper to the surface when transferring a design
Varnish for finishing coat on painting

The Little Lighthouse

This sunny seaside view combines the elements of sky, clouds, water, rocks, trees, and buildings. Contrast adds interest to the interaction of elements: sunlight/shadow, light value/dark value, smooth/rough. The rocks get their rough texture from unblended brush strokes, in contrast to the smooth transition from shadow to light on the round lighthouse tower.

Instructions begin on page 50

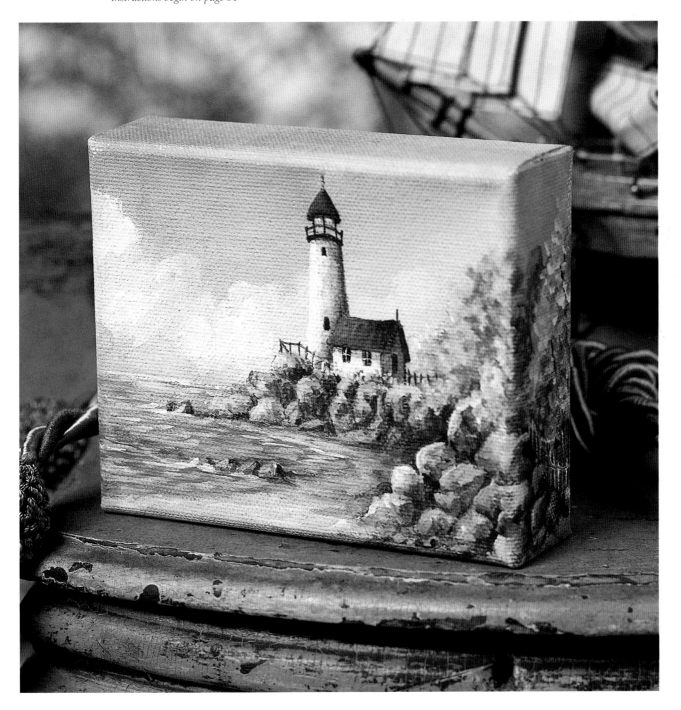

The Little Lighthouse

continued from page 49

MATERIALS LIST

Artist Pigment Acrylics:
Burnt Umber
Hauser Green Medium
Prussian Blue
Red Light
Warm White
Yellow Medium
Yellow Ochre

Brushes:
Flat – #2, #4, #8, #10, #16
Liner – #1

Surface:
Canvas with wrap-around edges, .
4" x 5"

COLOR MIXES:

Sky: three parts Warm White + one part Prussian Blue (4:1)

Rock Highlight: four parts Warm White + one part Yellow Ochre (4:1)

Tree Shade: one part Hauser Green Medium + one part Prussian Blue (1:1)

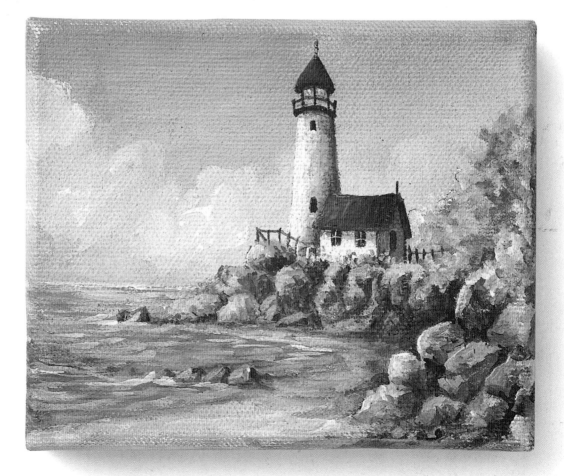

STAGE 1

Sky & Background:

1. Trace the pattern from the book onto tracing paper. Transfer only the horizon line to the canvas.
2. Brush the Sky Mix onto three quarters of the canvas or to the horizon line.
3. Darken the sky with just a touch of Prussian Blue at the horizon line.
4. While the sky is wet, paint the clouds with Warm White. Darken them slightly with Sky Mix at the horizon line. Let dry. *Refer to Summer Sky with Clouds in the "Painting Landscape Elements" section.*
5. Transfer the rest of the pattern onto the canvas.
6. Paint the water with Sky Mix. Lighten it a little at the horizon line with Warm White.

STAGE 2

Block in All Elements:

1. Using the liner brush or a small flat brush, paint Warm White waves, using short horizontal lines in the distant water.
2. Add a tiny touch of Prussian Blue to the Sky Mix and paint the darker horizontal water lines toward the foreground of the painting. Let dry.
3. Paint the walls of the lighthouse with Warm White.
4. Paint the roofs with Red Light.
5. Paint a wash of very thin Warm White on the upper lighthouse window.
6. Paint the trees. Using the corner of a small flat brush, dab on a little Hauser Green Medium.
7. While the paint is wet, highlight the trees with Yellow Medium as shown.
8. Make a wash of Yellow Ochre. Apply it to the rocks and the sand. Let dry.
9. Apply a second coat of thinned Yellow Ochre to the rocks. Let dry.

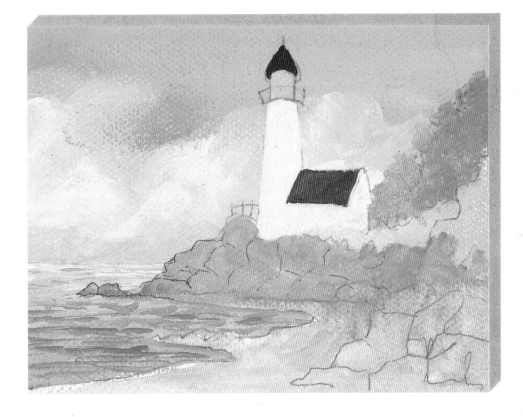

Continued on next page

STAGE 3

Add Details:

1. Shade the roofs with thinned Burnt Umber.
2. On the house, paint the roof overhang with Burnt Umber.
3. Shade the lighthouse and the end wall of the house with a float of Burnt Umber.
4. Add detail to the top of the lighthouse with the liner brush and thin Burnt Umber lines sliding down the roof.
5. Outline under the edge of both roofs with a thin line of Burnt Umber.
6. Using thinned Burnt Umber, shade the right sides of the rocks. Do not blend. *Refer to* Rocks on Dry Land *in the "Painting Landscape Elements" section.*
7. Highlight the rocks with the Rock Highlight Mix.
8. Darken the deepest shadows with more Burnt Umber.
9. Shade the trees by patting on the Tree Shade Mix.

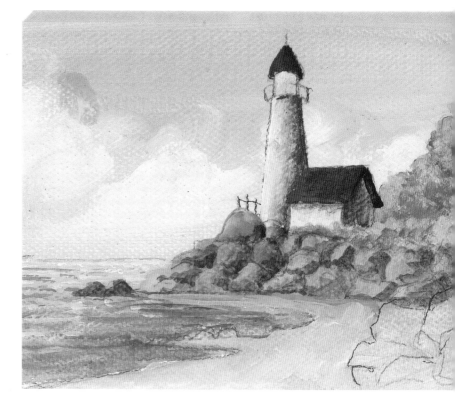

STAGE 4

Refine:

1. Paint the windows and the door with Burnt Umber. Let dry.
2. Add line work to the windows with thinned Warm White.
3. Using the liner brush and thinned Burnt Umber, paint the fence and the rails around the top of the lighthouse.
4. Highlight the fence and the rails with the tiniest touch of Warm White.
5. Lighten the sand by the water's edge with Warm White blended into Yellow Ochre. *Refer to* Ocean/Sand/Beach *in the "Painting Landscape Elements" section.*
6. Shade the sand next to the rocks with a float of Yellow Ochre. Let dry.
7. Apply a float of Burnt Umber shadow to anchor the rocks into the sand. Let dry.
8. Using your liner brush, pull Warm White waves in front of the rocks that are in the water.

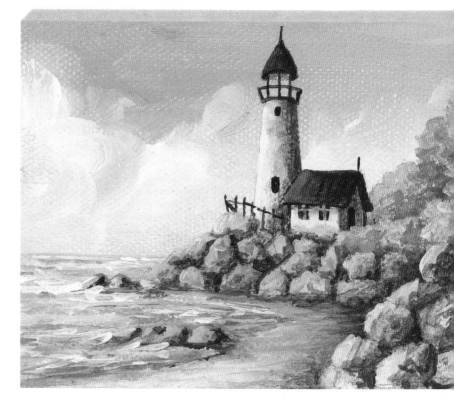

If you have the kind of canvas that wraps around the stretchers on the sides, simply extend the elements from the face of the canvas around the side: more sky, more water, more trees, and so on. You will not need a frame.

Pattern for The Little Lighthouse - Actual size

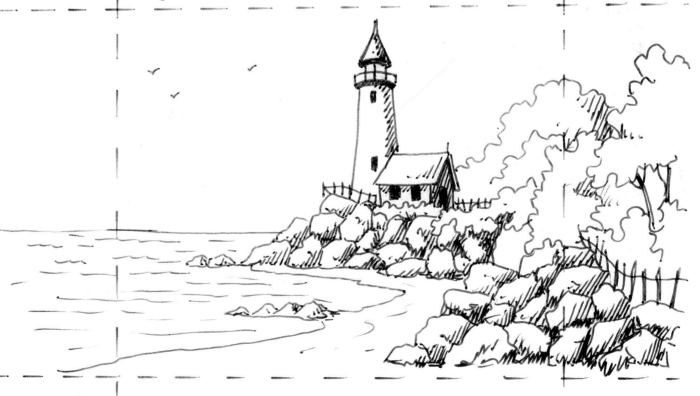

Forest in White

This is an excellent example of building a painting from the back to the front. Create the snowy background forest with wispy fan brush strokes, paint the distant tree trunks with grayed colors, and paint the trunk and branches of the large foreground tree with the most intense colors. To add textural interest, glue rice paper to the canvas before painting.

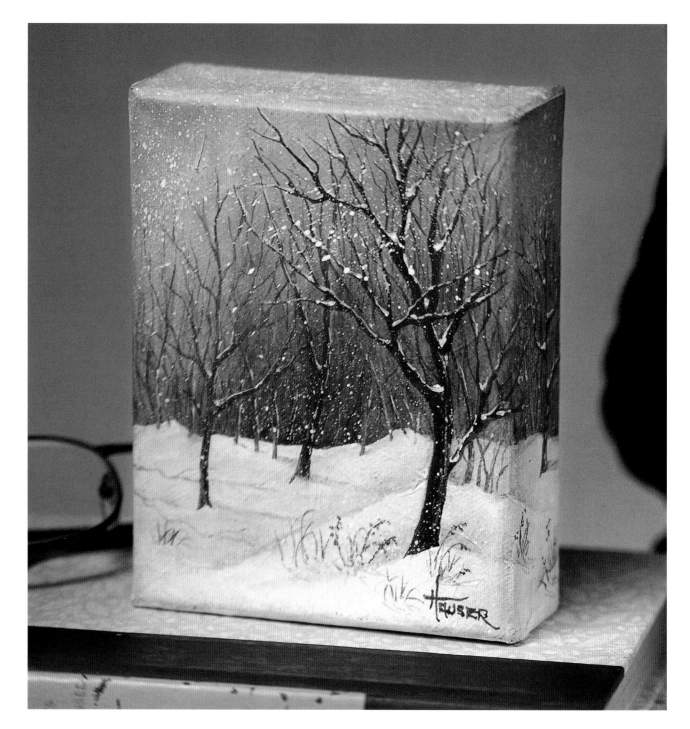

MATERIALS LIST

Artist Pigment Acrylics:

Burnt Umber

Prussian Blue

True Burgundy

Warm White

Yellow Ochre

Brushes:

Flat – #2, #4, #10, #16

Liner – #1

Surface:

Canvas with wrap-around edges,
4" x 5"

PREPARATION

1. Lightly sand the canvas and wipe with a tack rag.
2. Apply white glue to the front and sides of the canvas. Glue a piece of rice paper to the canvas and over the edges, mitering the corners of the paper so they fit neatly over the corners of the canvas. The rice paper adds texture to the completed painting. Let the glued paper dry thoroughly.

Continued on page 56

COLOR MIXES:

COLOR MIX:

Sky: three parts Warm White + a touch of Prussian Blue + a touch of Burnt Umber (3:touch:touch)

If you have the kind of canvas that wraps around the stretchers on the sides, simply extend the elements from the face of the canvas around the side.
You will not need a frame.

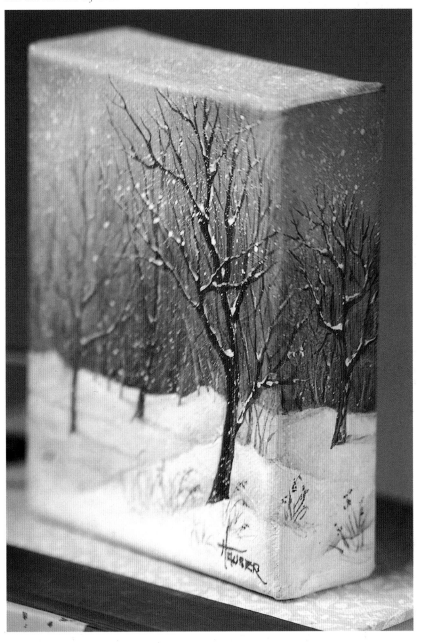

STAGE 1

Sky & Background:

Using the wash brush, apply the Sky Mix at the top and Warm White at the bottom. Using a light touch, blend from the bottom toward the top, then the top toward the bottom. Add more paint if needed. This creates the graded background. Let dry. *Refer to* Snowy Sky *in the "Painting Landscape Elements" section.*

STAGE 2

Block in All Elements:

1. Apply thinned Burnt Umber at the base of the background forest area.
2. Using the fan brush, pull the Burnt Umber up in a streaky, uneven manner as shown. Let dry.
3. Apply a very thin wash of Warm White over the trees and the sky to soften. Let dry.
4. With a liner brush and thinned Burnt Umber, paint the distant tree trunks as shown.
5. Highlight the trees with Warm White.
6. Paint the snowy ground area with Warm White.

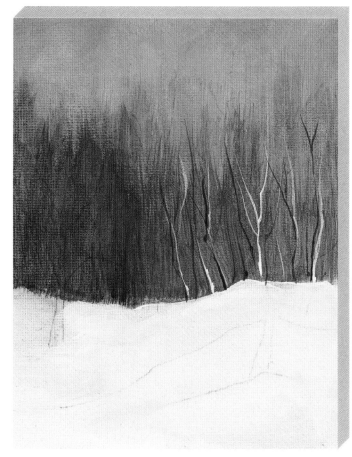

STAGE 3

Add Details:

1. Shade the white snow with the Sky Mix to create shadows.
2. Paint the tree closest to the front with the liner brush and slightly thinned Burnt Umber.
3. The tree closest to the front is the darkest. Thin the Burnt Umber a bit more to paint the trees that are farther away. Continue to thin the paint as you move toward the distant trees in the background.
4. Deepen the shadows in the snow around the bases of the trees with the Sky Mix.

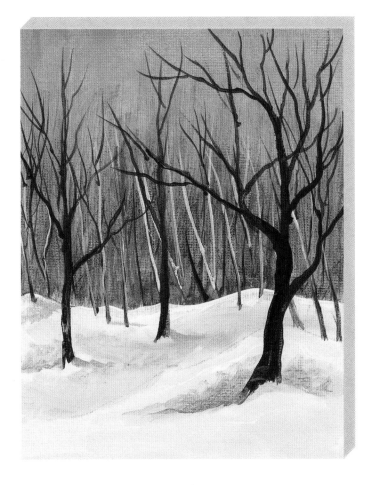

STAGE 4

Refine:

1. Highlight the trees and paint the snow on the branches with Warm White.
2. Paint the blades of grass with the liner brush and thinned Burnt Umber. *Refer to* Grass in Snow *in the "Painting Landscape Elements" section.*
3. Paint the shadows of the trees and grass with the liner brush and thinned Sky Mix as shown.
4. Allow the painting to dry. If desired, flyspeck using thinned Warm White and the toothbrush. *Refer to* Flyspecking *in the "Painting Techniques" section.*

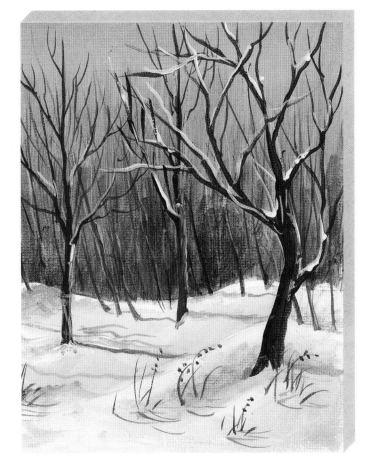

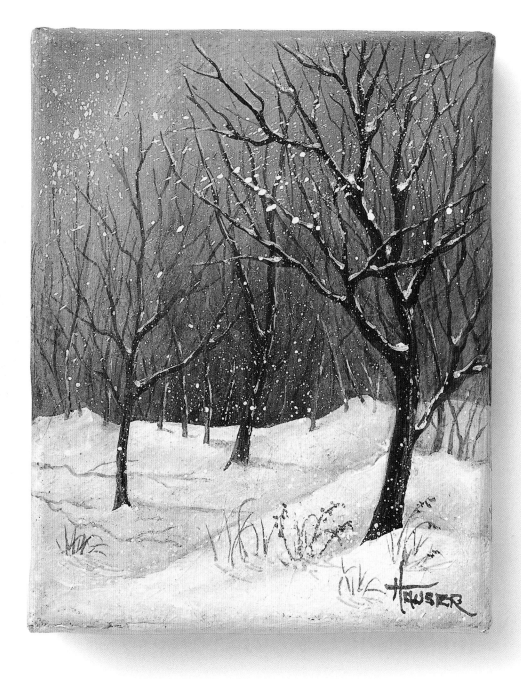

Pattern for Forest in White
Actual size

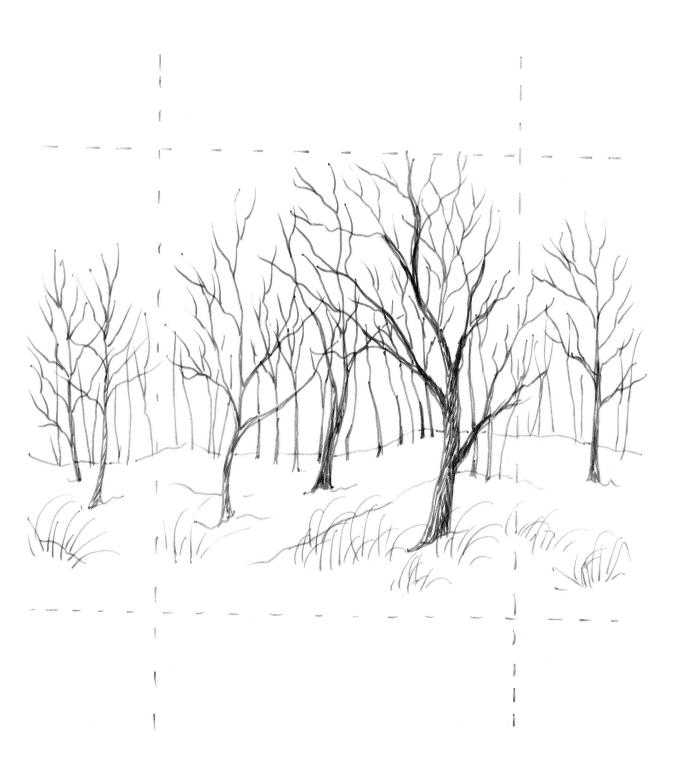

Autumn Sunrise

This miniature landscape is all about light. It captures a brief moment as the rays of the rising sun touch the trees and grasses, and the vivid sky is reflected in the creek. A loose, light touch gives the best results when you are painting grasses and bare tree branches.

MATERIALS LIST

Artist Pigment Acrylics:
Burnt Umber
Prussian Blue
Pure Orange
True Burgundy
Warm White
Yellow Medium

Brushes:
Flat – #4, #8, #10, 1"
Liner – #1

Surface:
Canvas board, 4" x 10"

COLOR MIXES:

Blue Sky: four parts Warm White + one part Prussian Blue (4:1)

Yellow Sky: two parts Yellow Medium + one part Warm White (2:1)

Distant Trees: one part Blue Sky Mix + a touch of True Burgundy + a touch of Burnt Umber (1:touch:touch)

Tree 1: one part Prussian Blue + a touch of Burnt Umber (1:touch)

Tree 2: one part Blue Sky Mix + a touch of Prussian Blue (1:touch)

Tree 3: one part Blue Sky Mix + a touch of True Burgundy (1:touch)

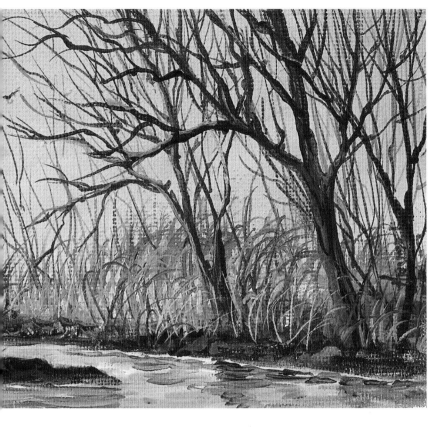

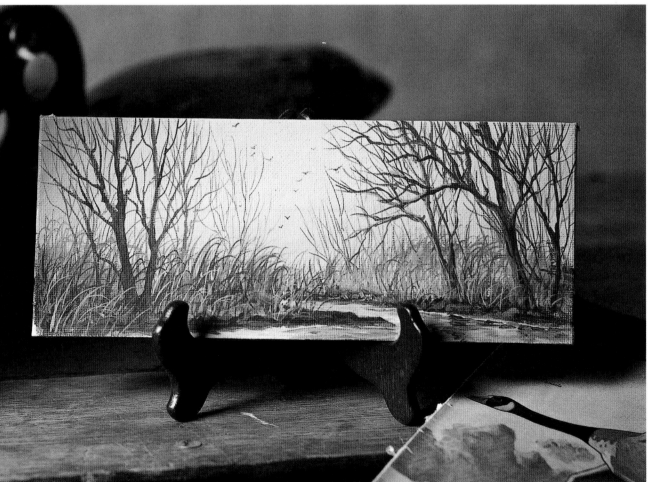

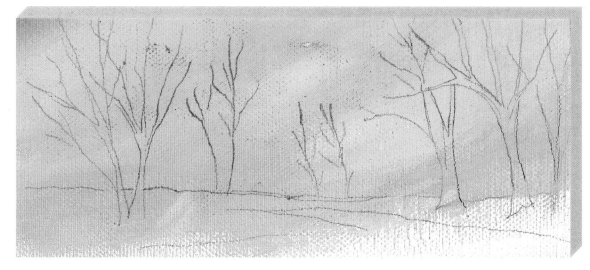

STAGE 1

Sky & Background:

Refer to Sunset/Sunrise Sky *in the "Painting Landscape Elements" section.*

1. Make the sky mixes.
2. Using a large flat brush, apply Blue Sky Mix to the sky diagonally as shown.

3. While the paint is wet, apply the Yellow Sky Mix on the same diagonal. Streak the yellow into the wet blue. Be sure you blend in the same diagonal direction.
4. While the sky is wet, apply just a touch of Pure Orange in the lower left corner of the canvas and a tiny touch of True Burgundy in the upper left corner.
5. Blend to soften the hard edges. Let dry.
6. Neatly trace and transfer the design.

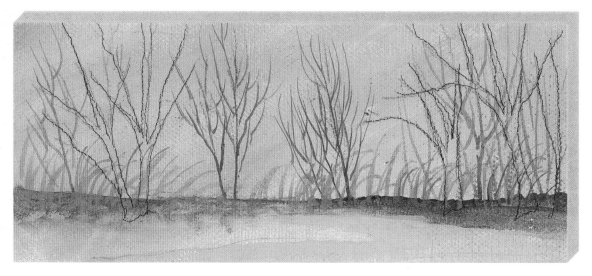

STAGE 2

Block in All Elements:

1. Shade the ground at the horizon line to represent distant trees with the Distant Trees Mix. The grass strokes will be pulled on top of this base color.
2. Make the Tree Mixes.
3. Thin some of the Tree 1 Mix and paint the distant trees to the right with the liner brush. Pull strokes from the base of the tree upward. *Refer to* Distant Bare Trees *in the "Painting Landscape Elements" section.*

4. Thin some of the Tree 2 Mix and paint the background trees in the center area with the liner brush. Pull strokes from the base of the tree upward.
5. Thin some of the Tree 3 Mix and paint the distant trees to the left with the liner brush. Pull strokes from the base of the tree upward.
6. Begin painting the distant grass with the liner and the thinned Tree Mixes. Pull strokes up and curve to the right.
7. Paint the water with the Blue Sky Mix. Let dry.

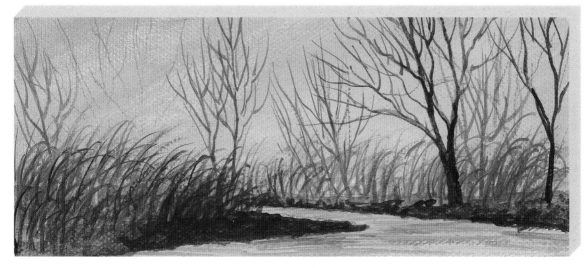

STAGE 3

Add Details:

1. Mix one part Blue Sky Mix + a touch of Prussian Blue (1:touch). Using short horizontal strokes, paint streaks of Yellow Medium and this darker Blue Sky Mix on the water. Do not blend; leave the little streaks going across the water horizontally. *Refer to* Creek *in the "Painting Landscape Elements" section.*

2. Dab Burnt Umber along the bank as shown.
3. Using the liner brush, continue painting the background grass with the thinned Tree Mixes. Pull strokes up and curve to the right.
4. Thin Pure Orange and Medium Yellow with water. Using your liner brush, pull thin, neat strokes of grass upward on both sides of the water as shown, curving to the right.
5. Using the liner, pull some Burnt Umber grass upward.

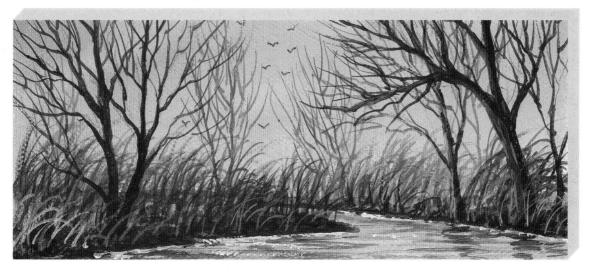

STAGE 4

Refine:

1. Using your liner brush, paint the larger trees in the foreground with thinned Burnt Umber.
2. Darken the foreground trees with touches of the Tree 4 Mix.
3. Mix one part Pure Orange + one part Yellow Ochre + three parts Warm White (1:1:3). Highlight the larger trees and branches on the right side of the water. They are reflecting the sunrise. Do not highlight the tree on the left.

4. Mix one part Yellow Medium + one part Warm White (1:1). Pull some grass in front of the trees and along the bank as shown.
5. Paint the birds with the liner brush and very thin Burnt Umber.
6. Mix three parts Burnt Umber + one part Prussian Blue (3:1). Paint the darkest shadows in the water with horizontal streaks.
7. Highlight the edge of the water where it touches the bank with Warm White.
8. Pull some Warm White streaks across the water for highlights as shown.

Pattern for Autumn Sunrise
Actual size

Pattern for The Waterfall
Actual size
Instructions begin on page 66

The Waterfall

Even a waterfall is easy to paint when you take it one step at a time and look closely at the painting worksheets. Create the ripples and reflections in the creek with horizontal strokes of dark and light colors. After you complete this little painting, you will have the basic skills and confidence you need to paint water in any landscape.

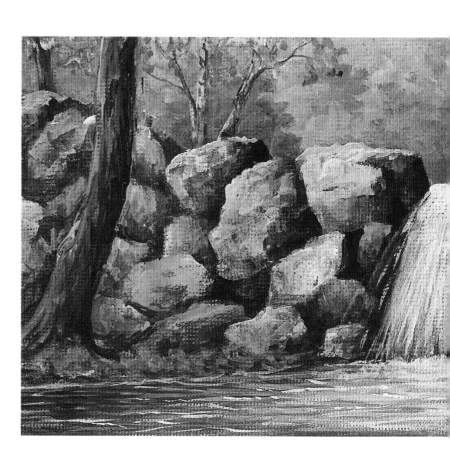

MATERIALS LIST

Artist Pigment Acrylics:
Burnt Umber
Prussian Blue
Pure Orange
Warm White
Yellow Medium
Yellow Ochre

Brushes:
Flat – #4, #10
Liner – #1

Surface:
Canvas, 4" x 10"

COLOR MIXES:

Sky: four parts Warm White + one part Prussian Blue (4:1)

Trees: one part Sky Mix + one part Yellow Medium (1:1)

Rock 1: one part Warm White + one part Yellow Ochre (1:1)

Rock 2: one part Burnt Umber + three parts Warm White (1:3)

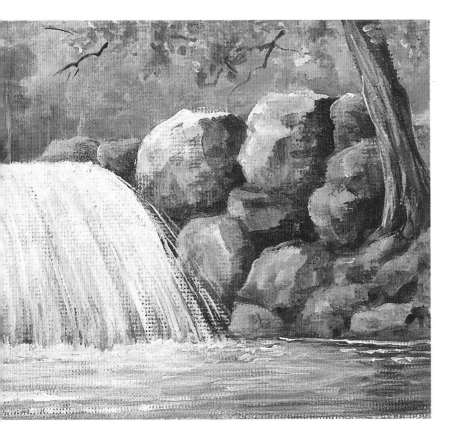

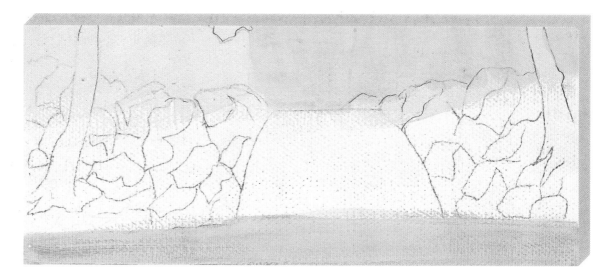

STAGE 1

Sky & Background:

1. Paint the upper third of the canvas with the Sky Mix. Let dry.
2. Neatly trace and transfer the pattern onto the canvas.
3. Paint the tree area with the Trees Mix.
4. Paint the water area with the Sky Mix. Let dry.

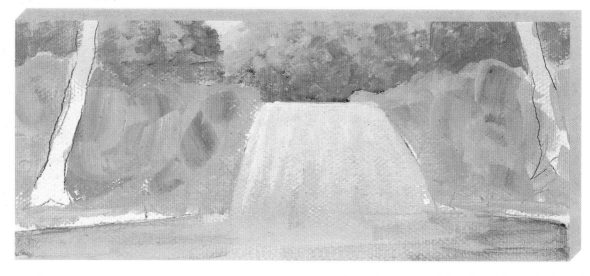

STAGE 2

Block in All Elements:

1. Pick up Prussian Blue and darken the tree foliage as shown.
2. While the paint is wet, pat some Yellow Medium on the upper left sides of the foliage as shown.
3. Paint the rocks with the two Rock Mixes, applying at random. Do not blend. Let dry. *Refer to* Rocks on Dry Land *in the "Painting Landscape Elements" section.*
4. Retransfer the rock shapes over the dried paint.
5. Paint the lower half of the waterfall with Sky Mix. *Refer to* Waterfall *in the "Painting Landscape Elements" section.*
6. Paint the upper half of the waterfall with Warm White.
7. While the paint is wet, pull each waterfall color into the other.

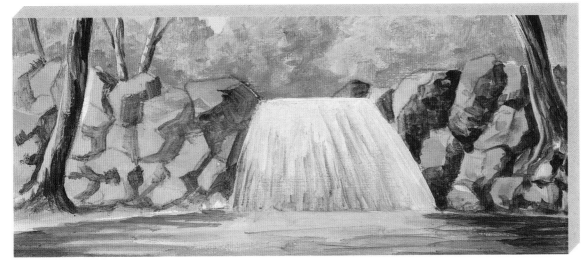

STAGE 3

Add Details:

1. Thin the Rock 2 Mix and add details to the tree trunks with the liner brush. Highlight the trunks with Warm White. Keep the hazy blue along the rock line.
2. Wash just a hint of Yellow Medium and Pure Orange on the foliage of the trees behind the waterfall.
3. Wash the shadow sides of the rocks with thinned Burnt Umber. Do not blend. Let dry.
4. Darken the rocks with more Burnt Umber. Pat or dry brush texture on the light rock surfaces.
5. Paint the dark tree trunks using the Rock 1 Mix.
6. While the paint is wet, pull streaks of Burnt Umber down the right side and streak/blend with the light mix.
7. Darken the right sides of the trunks with Burnt Umber as the paint starts to dry.
8. Paint the white tree trunks with Warm White. Shade with Burnt Umber.
9. Slightly darken the edges of the water with a wash of Prussian Blue.
10. Pull horizontal lines of thinned Prussian Blue and a touch of Burnt Umber from the sides of the water toward the center as shown.

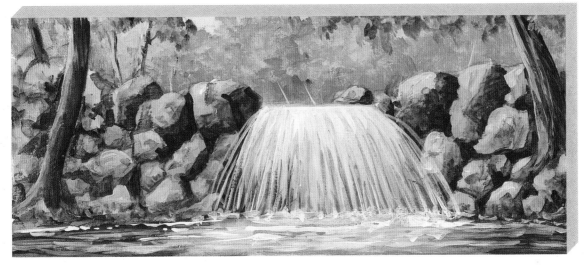

STAGE 4

Refine:

1. Highlight the rocks with thinned Warm White.
2. Pick up a little Yellow Medium and a little Pure Orange on your brush and pat at the top of the canvas to create autumn leaves.
3. Darken the autumn leaves by patting on Burnt Umber and Pure Orange.
4. Pat some orange and yellow colors at the base of the trees, close to the water's edge.
5. Use more Warm White for highlights and details on the waterfall.
6. Mix one part Sky Mix + a touch of Prussian Blue (1:touch). Pull up strokes into the waterfall.
7. Pull up a few touches of Burnt Umber into the waterfall, mostly on the left, as shown.
8. Highlight the water's edge and the ripples with Warm White.
9. Use very thin Prussian Blue to wash shadows on the tree trunks and the rocks. If the wash is too bright, immediately blot it with a towel or rag.

The Bay in Sepia

The most memorable black and white photographs get their dramatic impact from value contrast. Monochrome paintings work the same way, placing light against dark, dark against light, and concentrating on shape, brush strokes, and value.

MATERIALS LIST

Artist Pigment Acrylics:
Burnt Umber
Warm White

Brushes:
Flat – #6, #12
Liner – #1
Scrubby or scumbling brush

Surface:
Canvas, 3" x 7"

COLOR MIXES:

Medium Sepia: two parts Burnt Umber + one part Warm White (2:1)

Dark Sepia: one part Burnt Umber + one part Warm White (1:1)

Light Sepia: one part Burnt Umber + three parts Warm White (1:3)

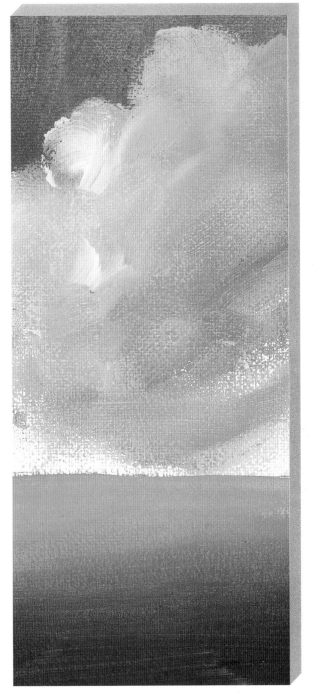

STAGE

Sky &
Background:

1. Transfer the horizon line onto the canvas.
2. Apply to the Medium Sepia Mix to the upper third of the sky area.
3. While the paint is wet, swirl in a Warm White cloud with an old scrubby brush or your finger. Pull down and soften to the left. *Refer to Stormy Summer Sky in the "Painting Landscape Elements" section.*
4. Pick up Burnt Umber and swirl a little below and to the right of the first cloud.
5. Repeat the Warm White clouds again as above.
6. Finish the base of the clouds with Burnt Umber and a touch of Warm White.
7. Apply the Dark Sepia Mix on the upper third of the water area. Clean the brush.
8. Apply Burnt Umber on the lower third of the water area.
9. Softly stroke back and forth to blend the two colors, so the water area is graded from dark to light. Let dry.
10. Transfer the pattern onto the canvas.

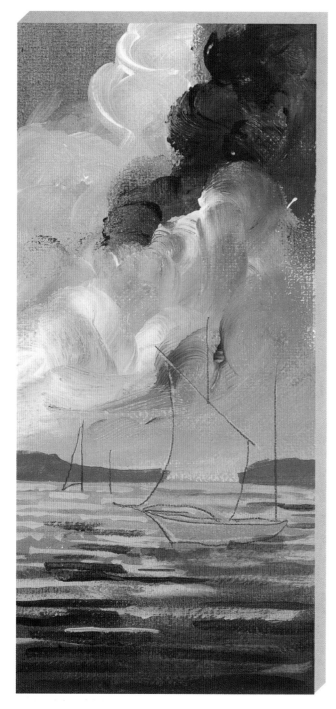

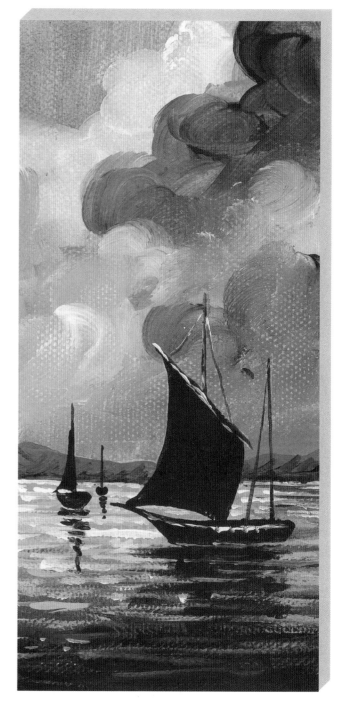

STAGE 2

Block in All Elements:

1. Mix three parts Burnt Umber + one part Warm White (3:1). Paint the distant hills.
2. Make short horizontal strokes or lines across the top of the water area using the Light Sepia Mix.
3. Add more strokes as you come downward, letting the lines get wider and farther apart, as shown.
4. Use Burnt Umber to make horizontal lines in the lower part of the water area.

STAGE 3

Add Details:

1. Shade the base of the distant hills with thinned Burnt Umber. Leave streaky; do not blend.
2. Make horizontal highlight lines through the water with thinned Warm White.
3. Paint each boat with Burnt Umber. The large boat may need two coats. Let dry.
4. Highlight the boats and sails with thinned Warm White as shown.
5. Paint reflections in the water with Burnt Umber streaks that begin below the boats and slowly taper off as shown.

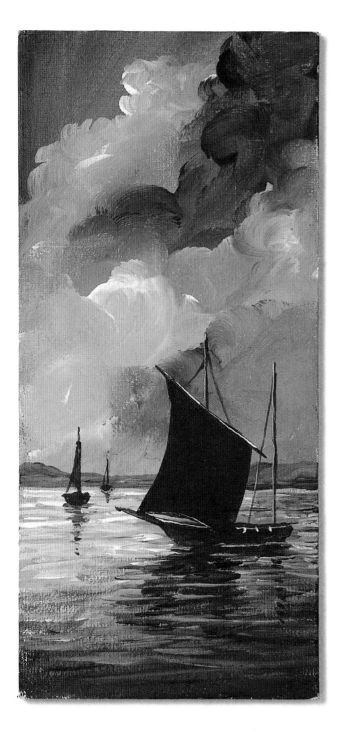

Pattern for The Bay in Sepia
Actual size

Chimney Rock

Why does that chimney rock formation stand out so strongly? Obviously, it is very large, almost the height of the canvas, but also its colors are deeper and its shadow is darker than those of the distant rock formations, the paint is applied more thickly, and it has more craggy detail to draw the eye. The clouds look so natural in the summer sky that you may not have noticed that the whitest clouds are positioned to provide maximum contrast with the dark values of the rock formation.

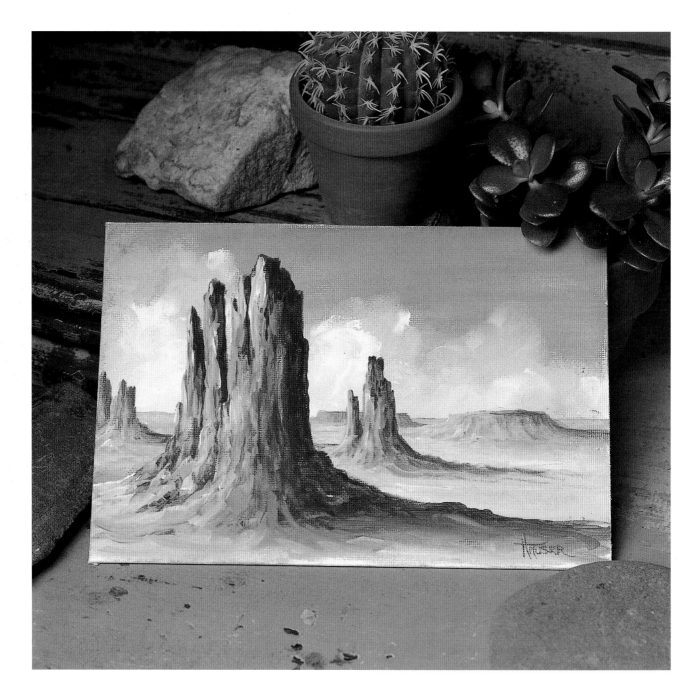

MATERIALS LIST

Artist Pigment Acrylics:

Alizarin Crimson

Burnt Sienna

Burnt Umber

Prussian Blue

Warm White

Yellow Ochre

Brushes:

Flat – #4, #6, #8, #10, #12, #14

Liner – #1

Wash – 1"

Surface:

Canvas board, 6" x 9"

COLOR MIXES:

 Sky: one part Warm White + a touch of Prussian Blue + a touch of Yellow Ochre (1:touch:touch) [SERENITY]

 Distant Horizon: one part Sky Mix + a touch of Alizarin Crimson + a touch of Warm White (1:touch:touch)

MINI-TIP:

If you paint six versions of the same mini landscape, they certainly would not look alike. Follow the worksheets closely the first time, then take off on your own.

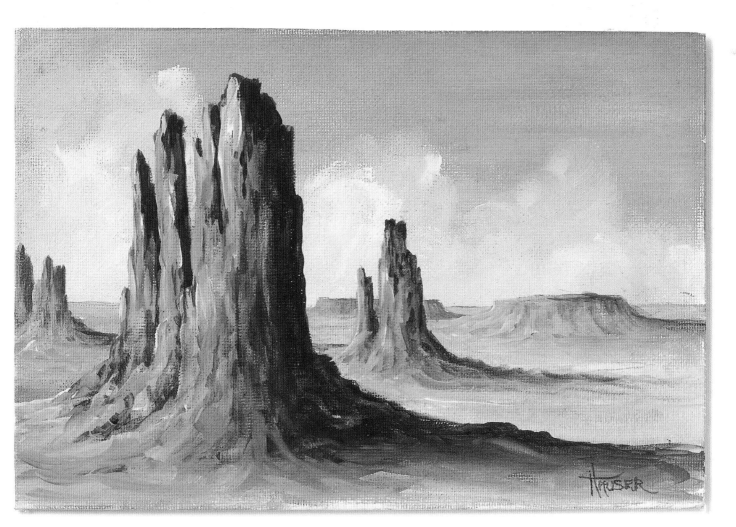

STAGE 1

Sky & Background:

1. Paint the sky with the Sky Mix on the top half of the canvas.
2. While the paint is wet, swirl on Warm White clouds. Let dry. *Refer to Summer Sky with Clouds in the "Painting Landscape Elements" section.*
3. Neatly trace and transfer the pattern.
4. Paint the distant horizon area as shown using the Distant Horizon Mix.

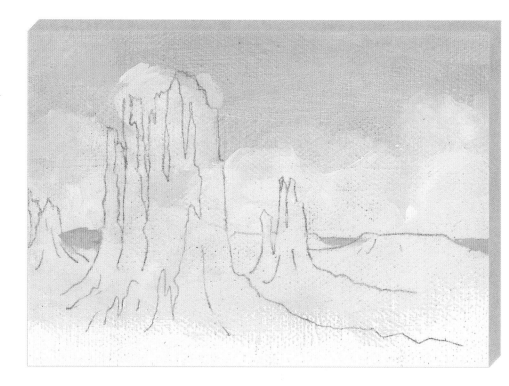

STAGE 2

Block in All Elements:

1. Mix one part Yellow Ochre + one part Warm White (1:1). Paint the mesas and the ground area.
2. Paint the tall chimney rocks with thinned Yellow Ochre. Pull it out into the base color of the ground. Do not blend at the base. *Refer to Rocks in the Desert in the "Painting Landscape Elements" section.*

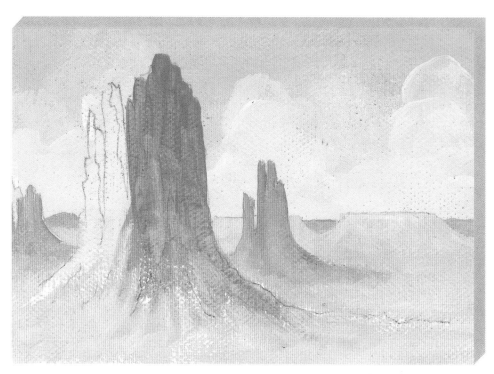

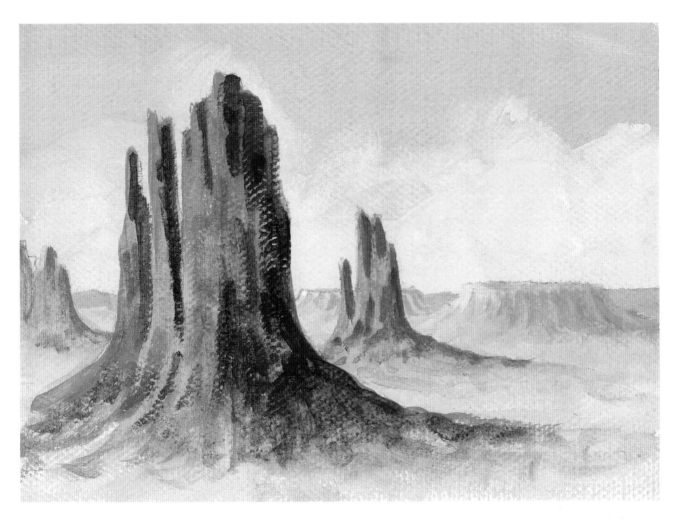

STAGE 3

Add Details:

1. Add a touch of Prussian Blue to the Sky Mix. Paint the shadow lines down the right sides of the flat-topped mesas. Pat the shadow color out into the sand at the base.
2. Add more shading to the mesas with a tiny touch of Sky Mix + Alizarin Crimson, as shown.
3. Highlight the left sides of the mesas with a mixture of one part Yellow Ochre + one part Warm White (1:1).
4. On the distant chimney rock formation on the far left, pull shadow lines down the right side with the Sky Mix. Do not blend.

5. Shade the chimney rock formation on the right with one part Yellow Ochre + one part Burnt Sienna (1:1). Pat the color to soften into the sand at the base of the rock.
6. Paint the large chimney rock formation in the foreground the same as the rock formation on the right. Apply paint more thickly, and do not blend.
7. Shade the large formation with more Burnt Umber and Burnt Sienna on the shadow side. Add tiny touches of Prussian Blue as shown.

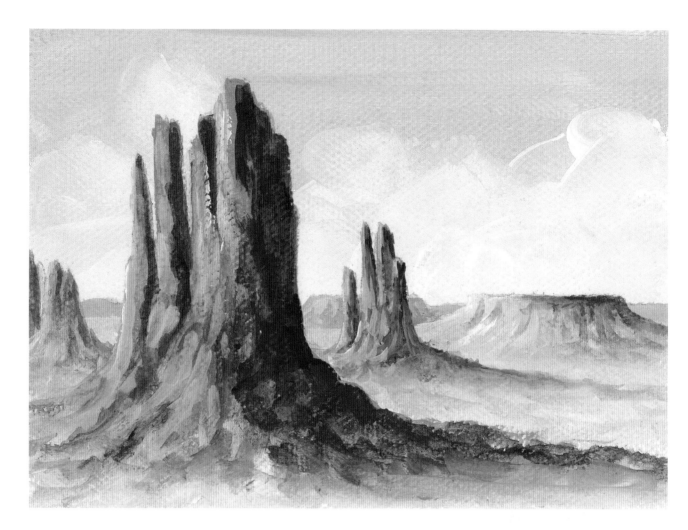

STAGE 4

Refine:

1. Mix one part Burnt Umber + one part Prussian Blue (1:1). Deepen the shadows on the right side of the nearest mesa as shown.
2. Add touches of this same shading color to the chimney rock on the right. Highlight the left sides with a mixture of one part Yellow Ochre + one part Warm White + a touch of Burnt Sienna (1:1:touch).
3. Paint shadows on the large chimney rock formation in the foreground with a mixture of one part Prussian Blue + one part Burnt Umber (1:1). Pat and pull streaks of Burnt Umber and Burnt Sienna at random to suggest rock shapes. The colors are not really blended; apply as short, choppy strokes that flare outward, then pat into the sand color. Add more of the sand color if needed.

MINI-TIP:

Vary the thickness of the paint when painting the chimney rock formations. The Yellow Ochre can be thick in some places, thin in other places. Note that the paint is thicker on the rock formation that is closest to the foreground, and thinner on the distant formations.

Pattern for Chimney Rock – Actual size

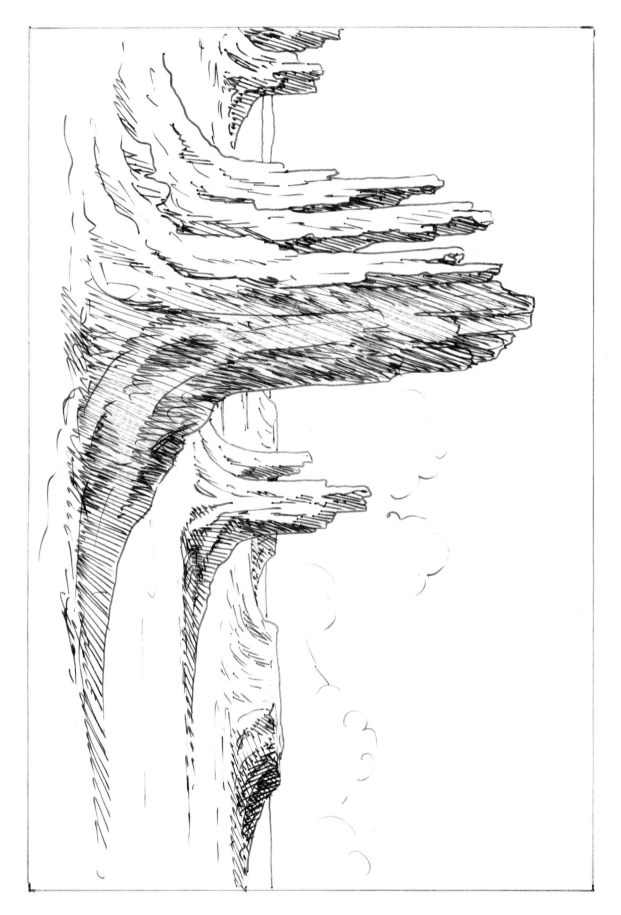

Little Church in the Snow

The little church is the focal point of this painting. The path leads
to its door, and its emotional appeal is enhanced by its
placement as an island of glowing, warm colors surrounded
by cool blues and whites. The reflection on the snow draws
attention to the warmth of the yellow-gold windows.

MATERIALS LIST

Artist Pigment Acrylics:
Burnt Umber
Olive Green
Prussian Blue
Pure Black
Pure Orange
Teal Green
Turner's Yellow
Warm White

Brushes:
Flat – #4, #8, #10
Liner – #1
Fan – #2
Wash – 1"

Surface:
Canvas board, 6" x 9"

Additional Supplies:
Toothbrush for flyspecking

COLOR MIXES:

Sky: three parts Warm White + one part Teal Green + a touch of Prussian Blue (3:1:touch)

Church Shading: two parts Turner's Yellow + one part Burnt Umber (2:1)

Pine Tree: one part Olive Green + one part Pure Black (1:1)

Reflected Light: three parts Warm White + one part Turner's Yellow (3:1)

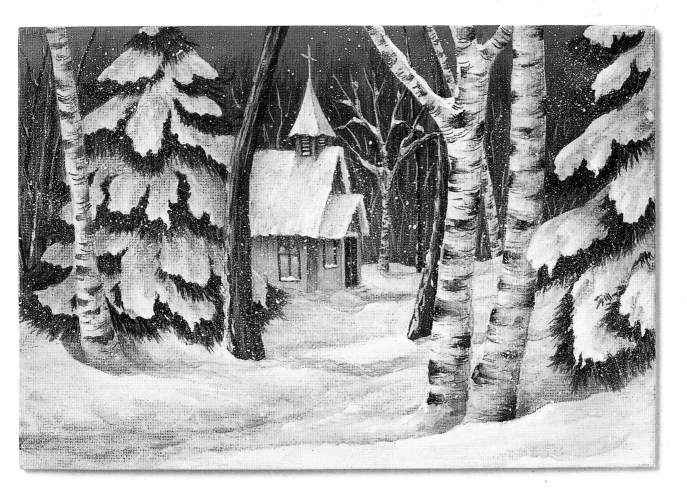

STAGE 1

Sky & Background:

1. Using the wash brush, paint the bottom of the canvas Warm White and apply the Sky Mix at the top. Using the large brush and a light touch, blend diagonally. Let dry.

2. Neatly trace and transfer the pattern onto the canvas.

3. Thin Burnt Umber and apply it to the background as shown. Pull up from the ground in a streaked and uneven manner to create the background trees. Be sure to keep the paint darker at the base. Let dry.

4. Apply a wash of thinned Warm White to soften the trees. Let dry.

5. Fill the liner brush with thinned Burnt Umber. Paint background tree trunks here and there. *Refer to Distant Bare Trees*

6. Highlight the background tree trunks with thinned Warm White.

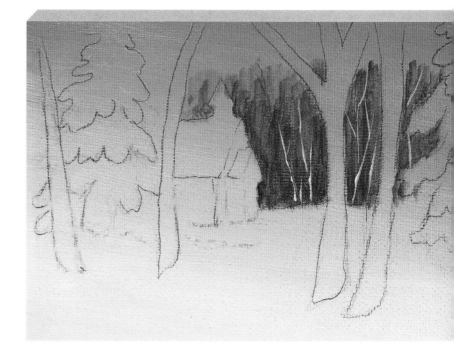

STAGE 2

Block in Elements:

1. Using a small flat brush, paint the left sides of the church building with Turner's Yellow.

2. Paint the shadowed right sides of the church building with the Church Shading Mix.

3. Paint the roof areas and the cross with the liner brush and Warm White.

4. Paint the windows with thinned Warm White.

5. Outline the windows and doors with the liner brush and thinned Burnt Umber.

6. Paint the dark tree trunks with Burnt Umber, then pull Sky Mix in streaks on the left sides for bark details. *Refer to* Tree Bark *in the "Painting Landscape Elements" section.*

7. Undercoat the birch tree trunks with Warm White.

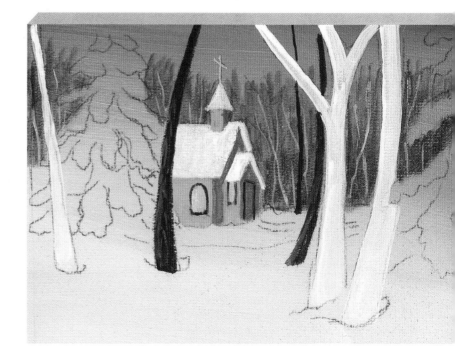

STAGE 3

Add Details:

1. While the birch trunks are wet, apply dots of Pure Black, then quickly, using a flat brush and/or your liner brush, pull the black into the wet white paint. *Refer to* Birch Trees *in the "Painting Landscape Elements" section.*
2. Shade under the rooflines with a float of Burnt Umber.
3. Block in the pine tree branches with Olive Green. *Refer to* Pine Trees with Snow *in the "Painting Landscape Elements" section.*
4. Highlight the pine tree branches with very thin streaks of Sky Mix.
5. Shade pine trees with thin lines of the Pine Tree Mix.
6. Carefully apply Warm White snow to the tops of the branches as shown. Shade with Sky Mix.

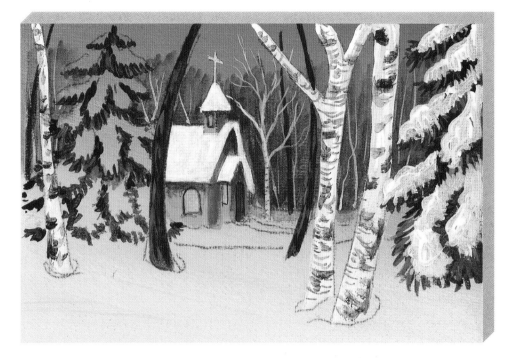

STAGE 4

Refine:

1. Paint the snow areas with Warm White. Shade the snow with Sky Mix, lightening the mix as needed with a little Warm White.
2. Shade the steeple with Sky Mix.
3. Using the Sky Mix, shade under the pine tree branches and on the right sides of the birch trees. Lighten all the snow shading with Warm White as needed.
4. To reflect a little light on the snow, paint the Reflected Light Mix under the church window.
5. Highlight the snow and trees with Warm White, as shown.
6. Allow the painting to dry completely. Flyspeck using thinned Warm White and an old tooth-brush. *Refer to* Flyspecking *in the "Painting Techniques" section.*

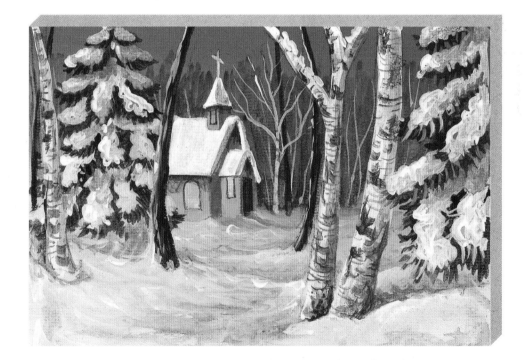

Continued on page 84

Church Window & Door Details:

1. After outlining the window separations with Burnt Umber, paint a tiny bit of Turner's Yellow on the window glass.
2. Blend Pure Orange into the Turner's Yellow at the lower portions of the glass.
3. Paint the two top glass sections with thinned Sky Mix.
4. Add a touch of snow on the windowsill with Warm White.
5. Paint the door area with a wash of Burnt Umber. Let dry.
6. Darken the top part of the door area with a float of Burnt Umber.
7. Using the liner brush, paint a line down the center with Turner's Yellow to divide the doors.
8. Paint the doorknobs with dots of Warm White. Add Warm White snow over the doors.

Pine Tree in Snow Detail:

Pull pine needle strokes on the lower sides of branches with dark Olive Green. Darken branches toward center. Add Warm White snow to top side of branches. Shade the snow with the Sky Mix.

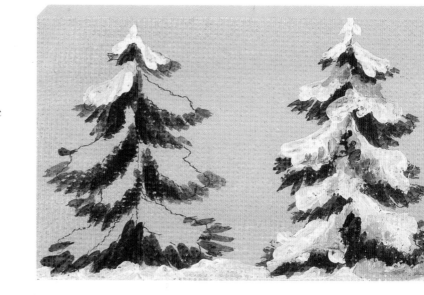

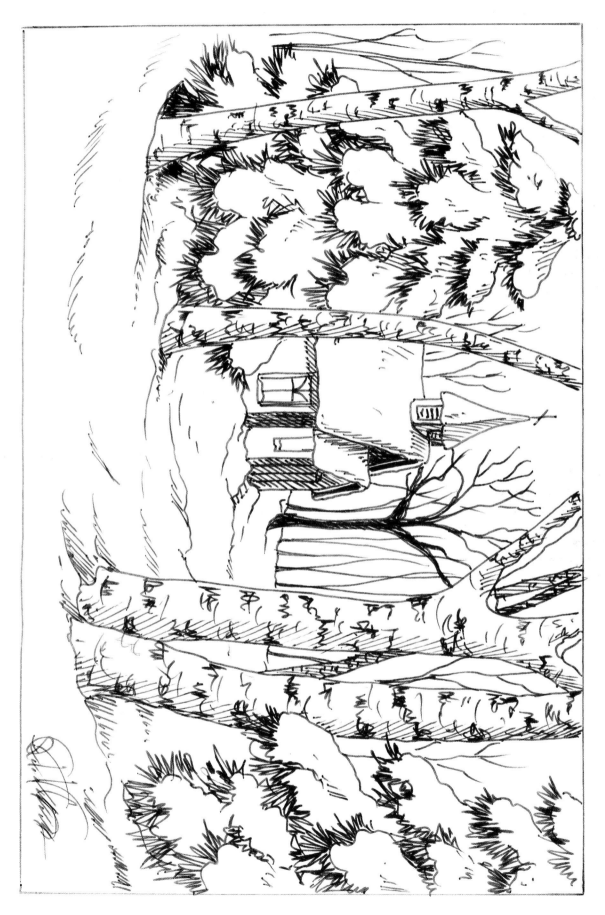

Country Summer

Look at this old tin roof! Reflections of the sky, dark streaks and highlights that show the ridges in the tin, and touches of rust all work together to create the impression of weather-beaten age. The birds add life to the view and, along with the diagonal movement of the road, keep the composition from becoming too static.

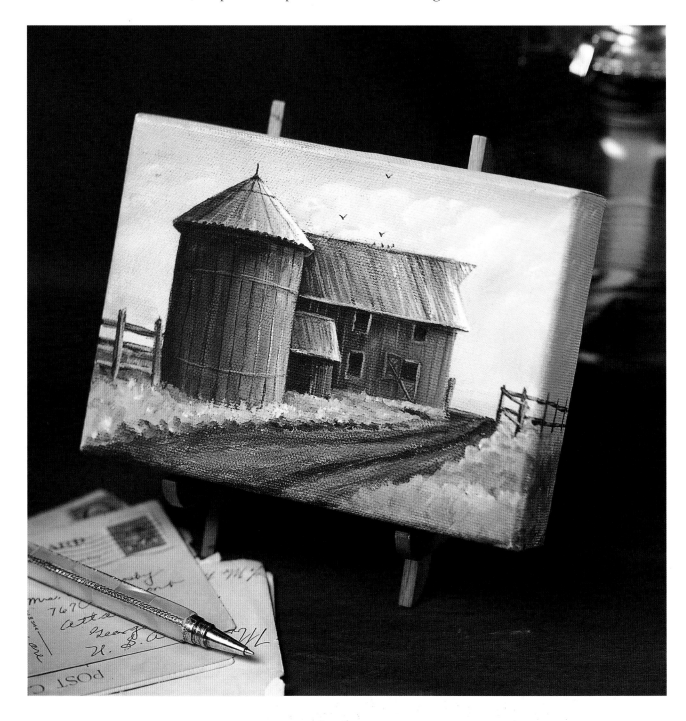

MATERIALS LIST

Artist Pigment Acrylics:
Burnt Sienna
Burnt Umber
Hauser Green Medium
Light Red Oxide
Medium Yellow
Payne's Gray
Prussian Blue
Raw Sienna
Warm White
Yellow Ochre

Brushes:
Flat – #4, #8, #12
Liner – #1

Surface:
Canvas with wrap-around edges,
5" x 7"

COLOR MIXES:

Sky: one part Warm White + a touch of Prussian Blue
(1:touch)

Grass: one part Warm White + one part Yellow Ochre
(1:1)

Tin Roof: three parts Warm White + one part Payne's
Gray (3:1)

Highlight: one part Warm White + a touch of Yellow
Ochre (1:touch)

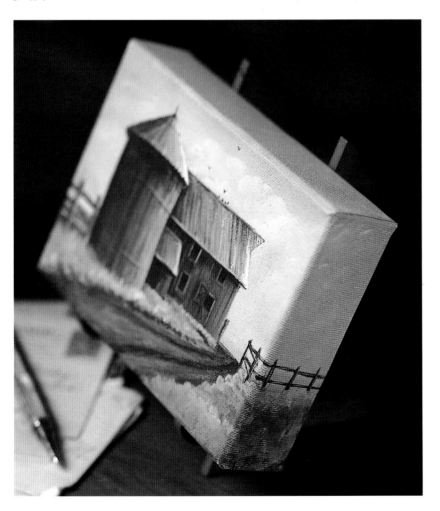

*If you have the kind of canvas that wraps
around the stretchers on the sides, simply
extend the elements from the face of the
canvas around the side.
You will not need a frame.*

STAGE 1

Sky & Background:

1. Trace the pattern and transfer the horizon line and road onto the canvas.
2. Paint the sky using the Sky Mix.
3. Blend in the clouds with Warm White.
4. Apply a thin wash of Burnt Umber to the road.
5. Shade the edges and most distant part of the road with more Burnt Umber.
6. Pat on the grass areas using the Grass Mix.
7. Wipe the brush and quickly pick up Sky Mix and a little Hauser Green Medium, working it into the wet grass color. Let dry.
8. Transfer the rest of the pattern.

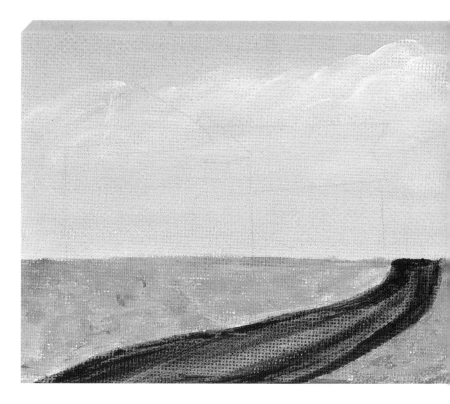

STAGE 2

Block in All Elements:

1. Apply streaks of Burnt Sienna, Raw Sienna, and Burnt Umber to create the ruts in the road.
2. Paint the barn and the side of the small building with Light Red Oxide. Shade the left sides and under the eaves with Burnt Umber.
3. Paint the silo with Raw Sienna. Shade the left side and under the eaves with Burnt Umber.
4. Paint the tin roofs with the Tin Roof Mix. Shade the left sides with Payne's Gray.
5. Paint the fence with the liner brush and thinned Burnt Umber.

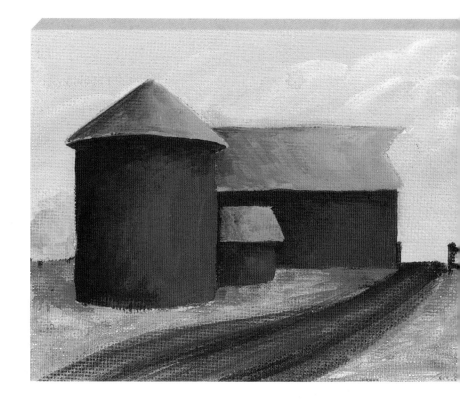

STAGE 3

Add Details:

1. Highlight the roofs of the barn and small building by blending in a touch of Warm White on their right sides.
2. Shade the roofs next to the silo with Burnt Umber.
3. Paint detail lines on the roofs with the liner and Warm White.
4. Paint the windows and the door on the small building with Burnt Umber.
5. Highlight the silo on the right side with Warm White, blending it in to the wet Raw Sienna.
6. Shade the tin roof of the silo on the dark side and shadow areas with Payne's Gray, as shown.
7. Highlight the silo roof with Sky Mix. Add additional highlights with Warm White as shown.
8. Add a touch of Warm White to Yellow Ochre. Highlight the fence posts and rails on their right sides.

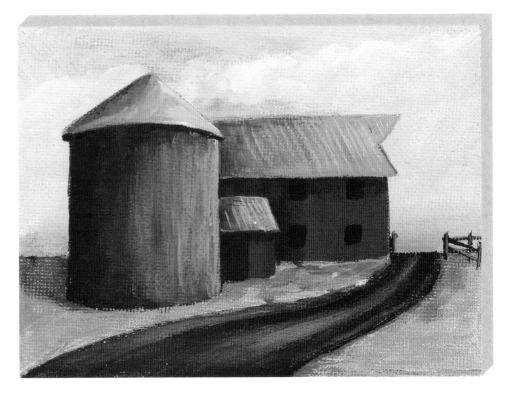

STAGE 4

Refine:

1. Outline the windows with thinned Warm White.
2. Outline the door on the small building with Burnt Umber. Highlight with Warm White.
3. Paint the barn window and door trim with Light Red Oxide + Warm White.
4. Paint the line work on the silo with the liner and Burnt Umber. Highlight the line work with the Highlight Mix, if desired.
5. Wash some Burnt Sienna on the tin roofs.
6. Paint the detail lines on the roofs and create the lower edge of the silo roof with the liner brush and thinned Burnt Umber. Highlight the roofs with the liner brush and Warm White.
7. Pat Hauser Green Medium on the grass area.
8. While the paint is wet, darken with touches of Prussian Blue as shown.

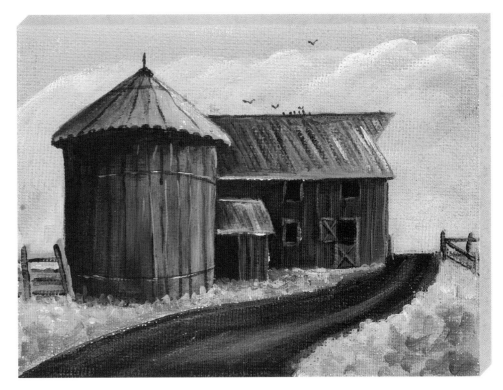

9. Mix two parts Medium Yellow + one part Warm White (2:1). Highlight the grass as shown.
10. Paint the fence next to the silo with Yellow Ochre and Warm White. Add details with the liner brush and thinned Burnt Umber.
11. Add the birds with the liner brush and thinned Burnt Umber.

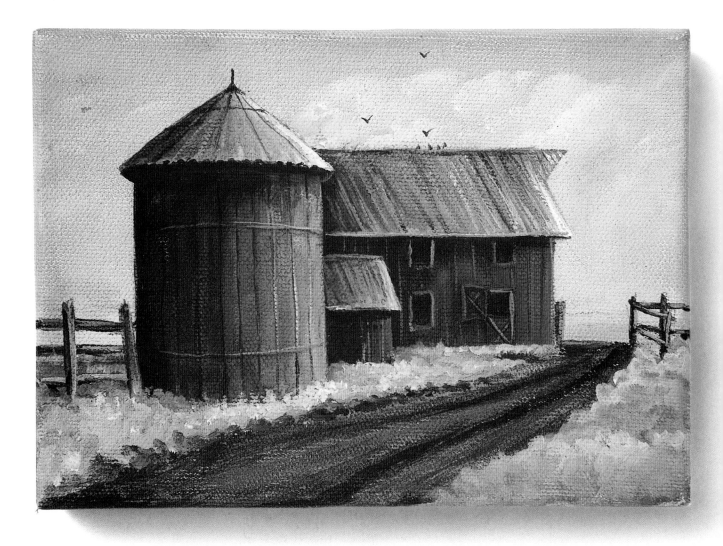

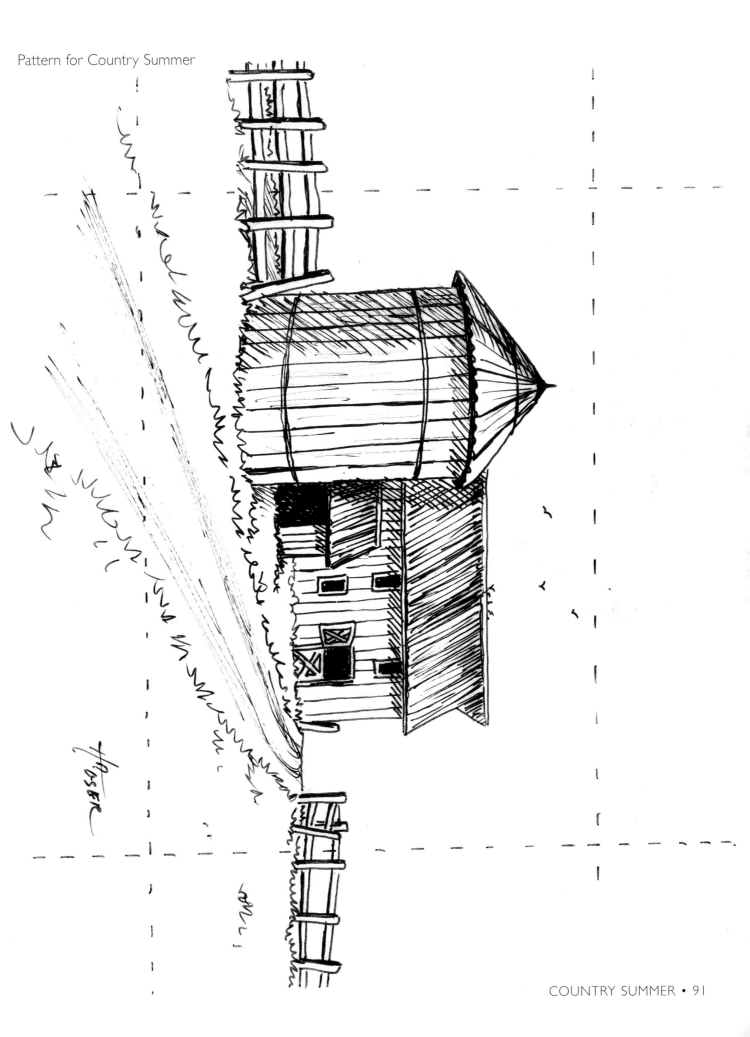

Durango

If you ever see aspens in autumn, you will never forget the glittering shimmer of their yellow-gold leaves. One way to capture the effect is to apply gold leaf to the canvas under the painted leaves. Apply paint with a sea sponge instead of a brush to achieve the loose, airy look of the foliage.

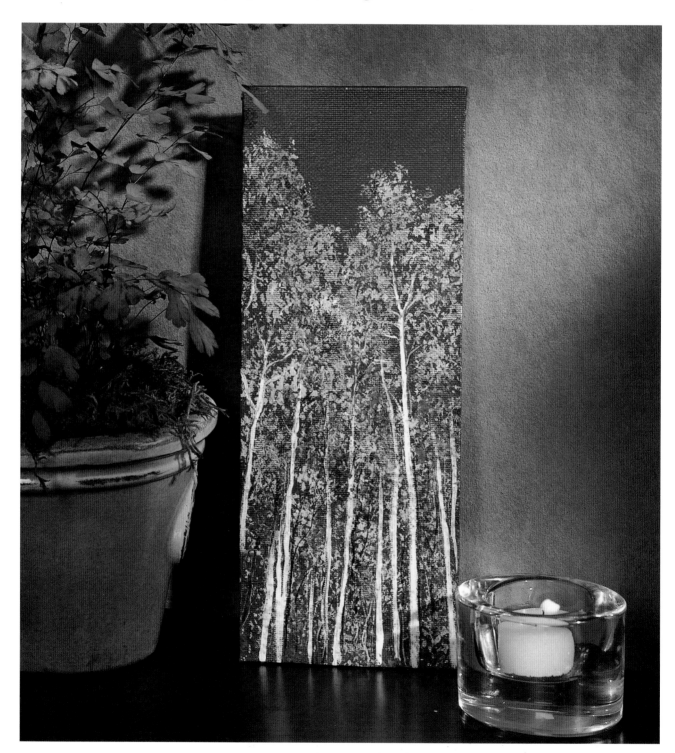

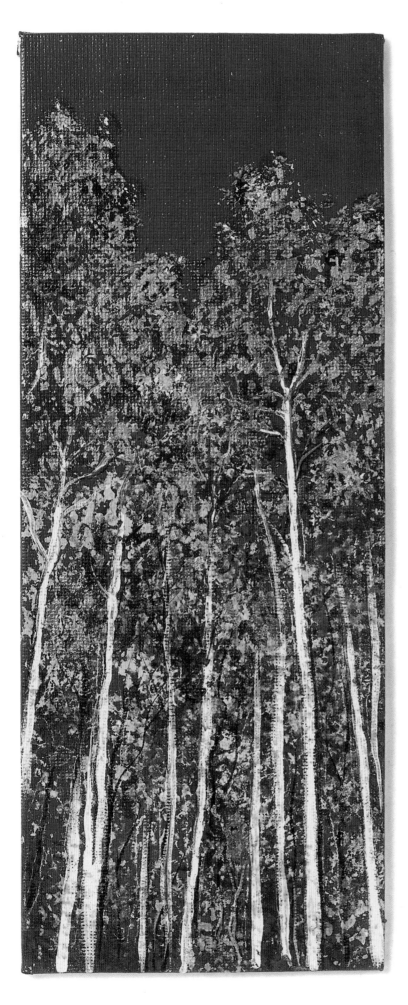

MATERIALS LIST

Artist Pigment Acrylics:
Asphaltum
Burnt Umber
Cobalt Blue
Naples Yellow
Titanium White
Turner's Yellow
Yellow Light

Brushes:
Flat – #2, #4
Liner – #1
Wash – 1"
Old brush for applying gold leaf
sizing

Surface:
Canvas board, 4" x 10"

Additional Supplies:
Gold leaf
Gold leaf sizing (adhesive)
Sea sponge
Soft, lint-free cloth

Continued on page 94

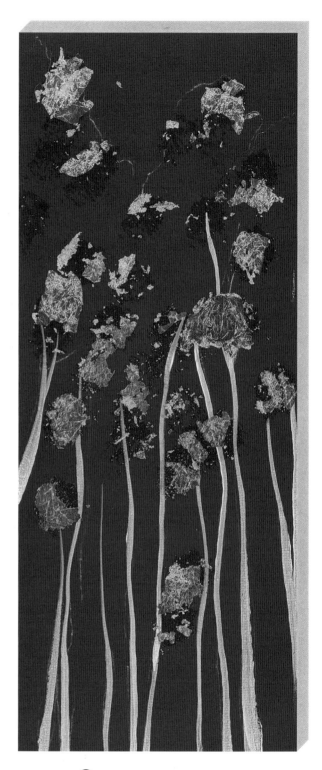

STAGE 1

Sky & Background:

1. Using the wash brush, paint the entire canvas with two or three coats of Cobalt Blue. Let dry after each coat.
2. Neatly trace and transfer the pattern for the tree trunks.
3. Using small flat brushes or the liner brush, paint the tree trunks with Titanium White. Let dry.

STAGE 2

Apply the Gold Leaf:

1. With an old, beat-up brush, pat on a little sizing (glue for the gold leaf) here and there.
2. Tear a sheet of gold leaf into little pieces. Sprinkle the pieces at random onto the sizing. Pat down with your finger. Let dry.
3. Burnish or rub the gold leaf with a soft rag.

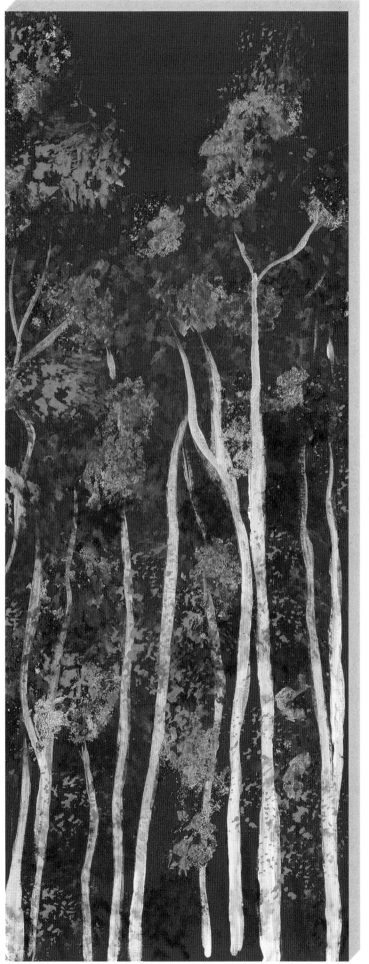

STAGE 3

Add Details:

1. Using the sponge, dab and tap Asphaltum in a very loose manner over the gold leaf.
2. Tap on some Turner's Yellow and Naples Yellow.
3. Tap on a few touches of Burnt Umber here and there.
4. Tap on a little Yellow Light, especially at the top. Let dry.

STAGE 4

Refine:

1. Repaint the tree trunks with mostly Titanium White. Here and there paint very fine lines of Burnt Umber at the base of the painting to represent trees in the background. Add some branches connecting to the shimmering leaves of the aspen trees.
2. Add a touch of Burnt Umber to a little Asphaltum. To paint the shadow leaves, dab on tiny touches of this mix at random, in a light and airy manner. Let dry.

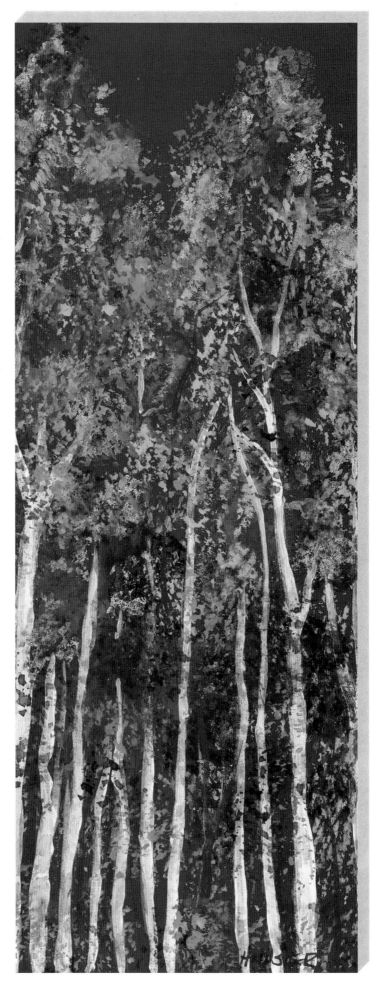

Pattern for Durango
Actual size

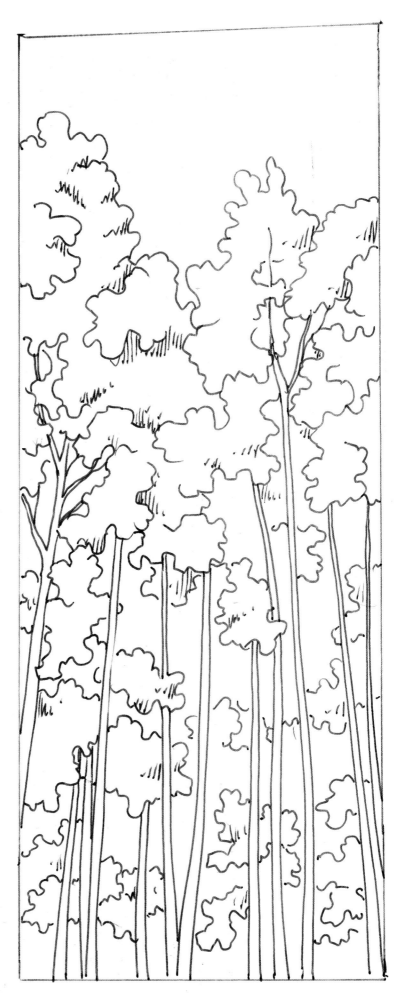

Serenity

When you want to get away from it all, there's no better place than a simple cabin with a view of distant mountains and infinite sky. Paint the mountains with shades of gray-violet. Because they are far away, you cannot see details; soft shadows suggest their massive shapes. Blend the mountains into the ground with a misty mingling of colors, including the blue of the sky.

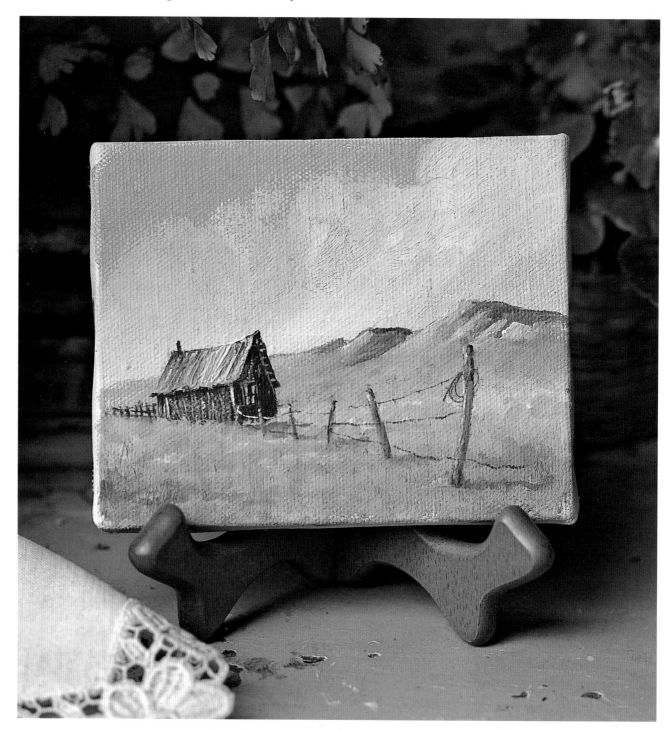

MATERIALS LIST

Artist Pigment Acrylics:
Burnt Umber
Prussian Blue
True Burgundy
Warm White
Yellow Ochre

Brushes:
Flat – #2, #4, #10, #16
Liner – #1

Surface:
Canvas, 4" x 5"

COLOR MIXES:

Sky: one part Warm White + a touch of Prussian Blue + a touch of Yellow Ochre (1:touch:touch)

Mountain: one part Sky Mix + a touch of True Burgundy + a touch of Warm White (1:touch:touch)

Ground: one part Warm White + a touch of Yellow Ochre (1:touch)

Dark Sky: one part Sky Mix + a touch of Prussian Blue (1:touch)

Wall Highlight: two parts Yellow Ochre + one part Burnt Umber (2:1)

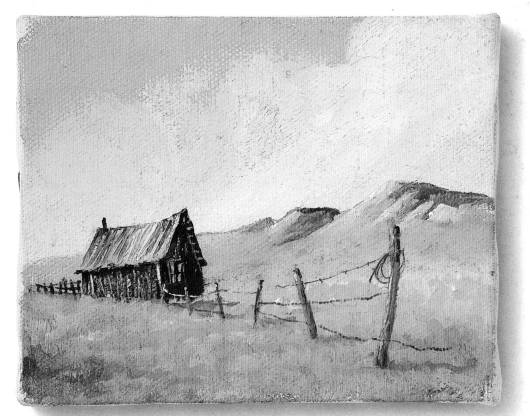

STAGE 1

Sky & Background:

1. Trace and transfer the mountain and horizon lines onto the canvas.
2. Paint the sky with the Sky Mix.
3. Paint some of the Dark Sky Mix at the bottom of the horizon line as a base for the mountains.
4. While the paint is wet, swirl in the clouds with Warm White. *Refer to* Summer Sky with Clouds *in the "Painting Landscape Elements" section.*
5. Paint the mountains as shown using the Mountain Mix.

STAGE 2

Mountains & Ground:

1. While the mountains are wet, pull Warm White down the left side of each mountain as shown. Keep the mountains light at the base.
2. Mix Mountain Mix + a touch of Prussian Blue (1:touch). Pull this shadow color down the right sides of the mountains. Let dry.
3. Paint the ground using the Ground Mix.
4. While the ground is wet, pat Sky Mix lightly into the paint. Keep adding a little more Sky Mix to the ground color as you work down, making the base of the canvas and both lower corners darker.

STAGE 3

Add Details:

1. While the ground is wet, dab on a little Yellow Ochre and Sky Mix as shown. Let dry.
2. Transfer the little house and the fence.
3. Paint the walls of the house with Burnt Umber.
4. Highlight the left wall using the Wall Highlight Mix, pulling vertical strokes downward to suggest boards.
5. Paint the window on the right side with Warm White.
6. Paint the tin roof with the Sky Mix. Shade by streaking a little Burnt Umber down the slope of the roof. Highlight with Warm White lines.
7. Paint the chimney with Burnt Umber. Highlight with Warm White.
8. Paint the roof overhang with Burnt Umber. Add Yellow Ochre detail lines with the liner brush.
9. Paint the fence posts to the right of the house with Yellow Ochre. Shade with streaks of Burnt Umber on the right sides. Do not blend.
10. Paint the fence to the left of the house with Burnt Umber.
11. Paint the fence wire with the liner brush and very thin Burnt Umber.
12. Float shadows under the fence posts with a wash of Prussian Blue, as shown.

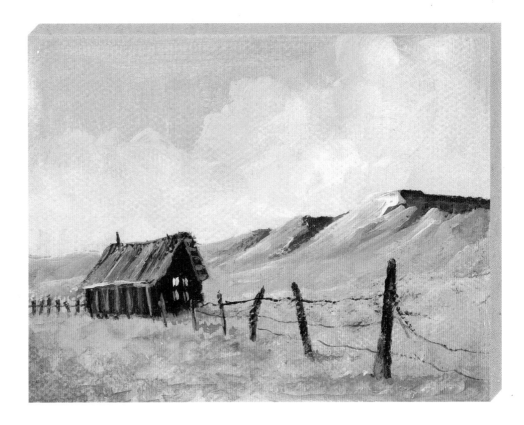

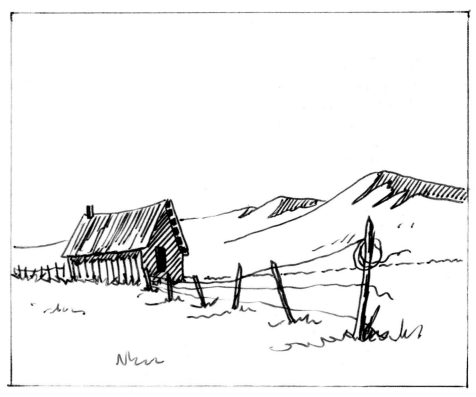

Pattern for Serenity
Actual size

Priscilla's Beach
Before the Storm

The sparkling aqua water reflects the sunny sky on a lovely afternoon at the beach. The bright highlights on the sand show the direction of the sun's rays. Those big, puffy clouds and the sea oats bending in the breeze hint that a thunderstorm is on the way.

MATERIALS LIST

Artist Pigment Acrylics:

Aqua Burnt Umber
Olive Green Payne's Gray
Prussian Blue Warm White
Yellow Ochre

Brushes:

Flat – #2, #4, #8, #10
Liner – #1
Fan – #2
Wash – 1"
Scrubby or scumbling brush

Surface:

Canvas with wrap-around edges,
8" x 10"

Additional Supplies:

Craft knife and sharp blades

COLOR MIXES:

 Ice Blue: three parts Warm White + a touch of Prussian Blue + a touch of Burnt Umber (3:touch:touch)

 Sky: three parts Warm White + one part Prussian Blue (2:1)

 Water: one part Aqua + two parts Warm White (1:2)

 Dark Grass: one part Olive Green + one part Ice Blue Mix (1:1)

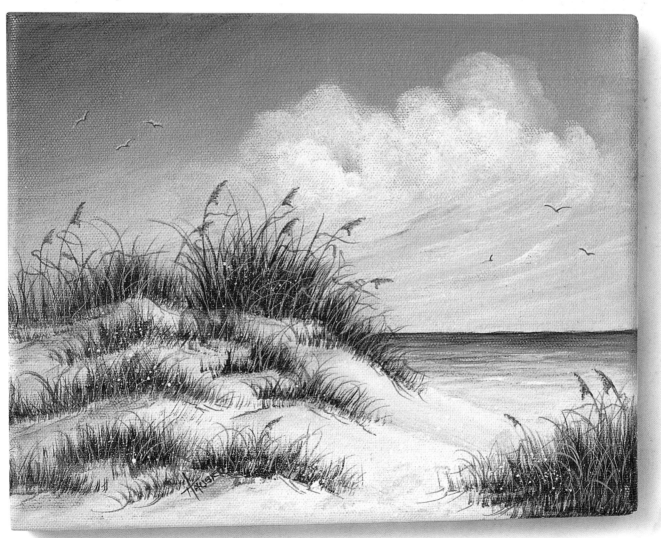

STAGE 1

Sky & Background:

1. Paint the sky with the Sky Mix.
2. Apply Warm White in the lower two-thirds of the canvas. Let dry.
3. Neatly trace and transfer the pattern onto the canvas.

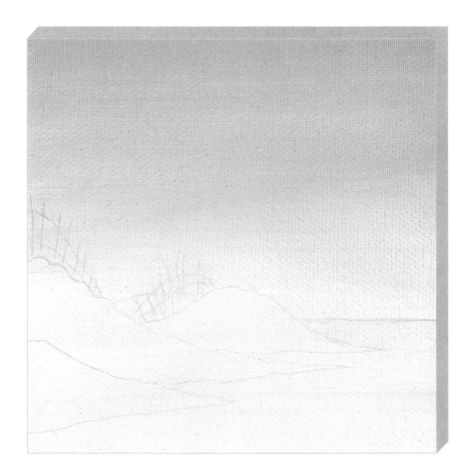

STAGE 2

Block in All Elements:

1. Using Warm White and the scrubby brush, scrub the clouds in, pulling down and to the left at the base of the clouds as shown. Let dry.
2. Mix one part Ice Blue Mix + a touch of Payne's Gray (1:touch). Float a wash of this mix into the upper left corner of the sky.
3. Paint the water with the Water Mix.
4. Shade the water at the horizon line with a little Payne's Gray.
5. Apply horizontal streaks of Warm White to represent the gentle waves. Blend into the white sand of the beach.
6. Add a touch of Yellow Ochre to Warm White. Paint the sand dunes.
7. Highlight the tops of the dunes with Warm White.

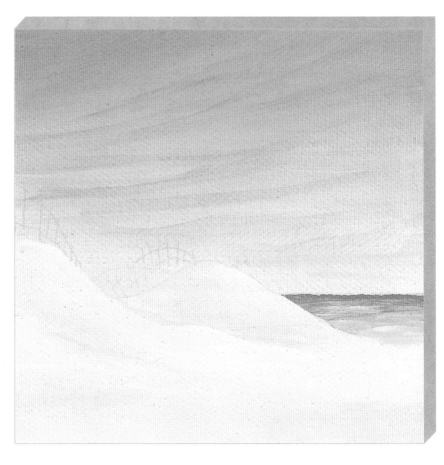

STAGE 3

Add Details:

1. Shade the dunes with a wash of the Sky Mix.
2. Using the fan brush and the Dark Grass Mix, pull wisps of grass upward from the dunes.

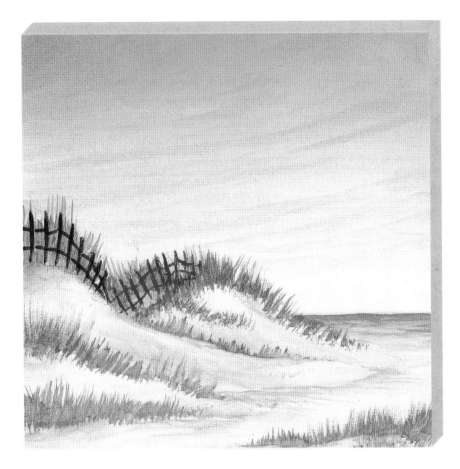

STAGE 4

Refine:

1. Using the fan brush and Olive Green, pull up wisps of grass again.
2. Detail the grass and paint the sea oats using a liner brush and a very thin mix of the Grass Mix.
3. Highlight the sea oats with Yellow Ochre. Let dry.
4. Dampen the grass with clean water. Using the tip of a sharp craft knife blade, carefully scratch out some grass.
5. Paint the seagulls with the liner brush and Payne's Gray. Highlight with Warm White.

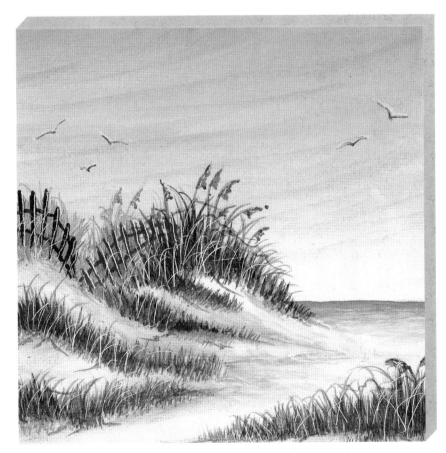

Pattern for Priscilla's Beach Before the Storm
Enlarge @125% for Actual Size

Pattern for Priscilla's Beach After the Storm

Enlarge @125% for Actual Size. Instructions begin on page 108.

Priscilla's Beach
After the Storm

Here is the same beach after the storm. Notice how the weather affects light, colors, and values in the landscape. The sky is now a cool gray, the water is darker, and the dunes no longer reflect bright sunlight. A fence has been erected to keep the sand in place.

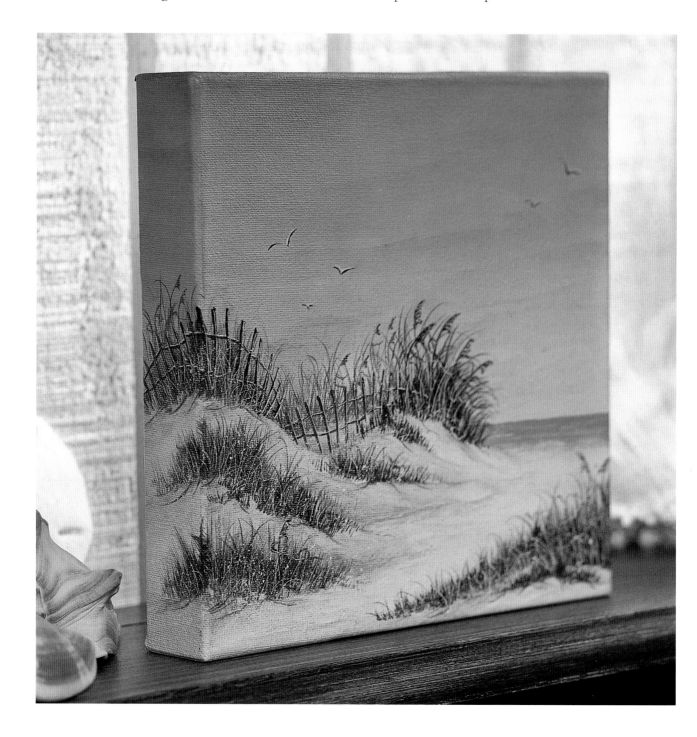

MATERIALS LIST

Artist Pigment Acrylics:

Aqua

Burnt Umber

Olive Green

Payne's Gray

Prussian Blue

Pure Black

Warm White

Yellow Ochre

Brushes:

Flat – #4, #8, #10, #12, #16, #20

Liner – #1

Fan – #2

Wash – 1"

Surface:

Canvas with wrap-around edges, 8" x 8"

Additional Supplies:

Craft knife and sharp blades

Toothbrush for flyspecking

COLOR MIXES:

Ice Blue: three parts Warm White + a touch of Prussian Blue + a touch of Burnt Umber (3:touch:touch)

Sky: one part Ice Blue Mix + a touch of Payne's Gray (1:touch)

Water: one part Aqua + two parts Warm White (1:2)

Grass: one part Olive Green + one part Ice Blue Mix (1:1)

Grass Shadow: one part Olive Green + a touch of Pure Black (1:touch)

STAGE 1

Sky & Background:

See Stage 1 example with "Before the Storm" instructions.

1. Paint a graded background. Apply Ice Blue Mix to the top third of the canvas. Apply Warm White in the lower two-thirds. Blend horizontally with a large flat wash brush. Let dry.
2. Neatly trace and transfer the pattern onto the canvas.

STAGE 2

Block in All Elements:

See Stage 2 example with "Before the Storm" instructions.

1. Float a wash of the Sky Mix into the upper left corner and neatly streak it horizontally across the sky. This gives the look of the sky after the storm.
2. Paint the water with the Water Mix.
3. Shade the water at the horizon line with a float of Payne's Gray.
4. Apply a few horizontal streaks of Warm White to represent the waves. Blend into the white sand at the edge of the water.
5. Add a touch of Yellow Ochre to Warm White. Paint the sand dunes.
6. Highlight the tops of the dunes with Warm White.

STAGE 3

Add Details:

See Stage 3 example with "Before the Storm" instructions.

1. Shade the dunes with a wash of the Sky Mix.
2. Using the fan brush, load it with the Grass Mix and pull wisps of grass upward from the dunes. This grass will appear shadowy. It should be darker than the dark shading in the sky.
3. Load the fan brush with the Grass Shadow Mix, pull up wisps of grass again.
4. Using the liner brush, paint the fence with Burnt Umber. Let dry.
5. Float thinned Ice Blue Mix over the fence on the right to give a misty, far-away look.
6. Highlight the fence posts with fine lines of Warm White.

STAGE 4

Refine:

See Stage 4 example with "Before the Storm" instructions.

1. Detail the grass and paint the sea oats using a liner brush and a very thin mix of the Grass Mix.
2. Highlight the sea oats with Yellow Ochre. Add a few grass strokes with thinned Yellow Ochre. Let dry.
3. Dampen the grass with clean water. Using the tip of a sharp craft knife blade, carefully scratch out some grass as shown.
4. Paint the seagulls with the liner brush and Payne's Gray. Highlight with Warm White.
5. Allow the painting to dry. Flyspeck with Warm White and an old toothbrush. *Refer to* Flyspecking *in the "Painting Techniques" section.*

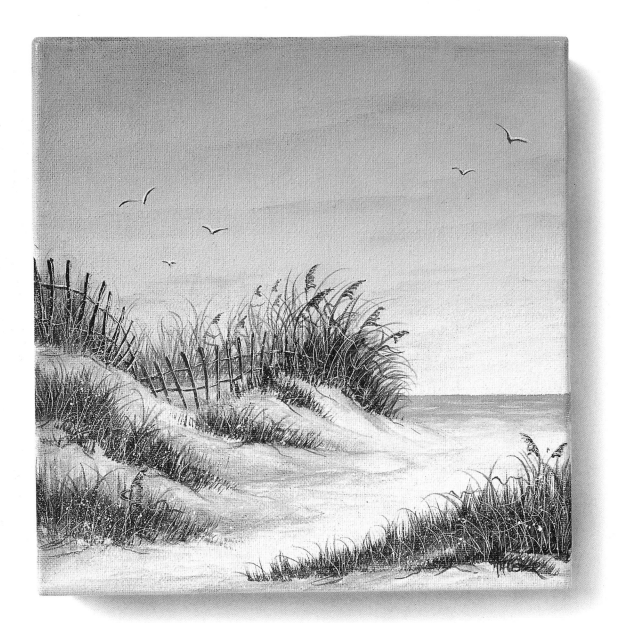

The Farm

This mini landscape celebrates springtime in the country. The foliage on the trees around the barn is brightened with yellow, and the large tree in the foreground is not fully leafed out. Notice that distant trees and hills take on blue tones and become misty as they recede into the background.

Instructions begin on page 112.

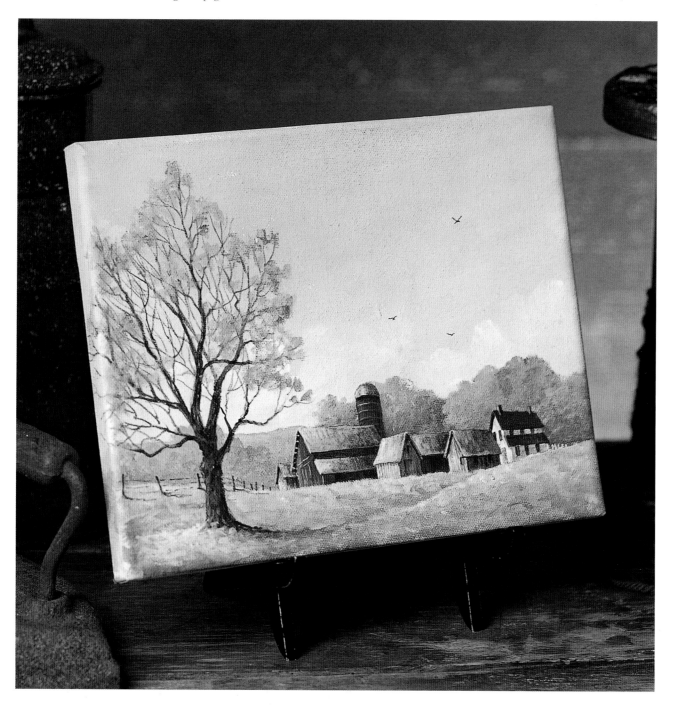

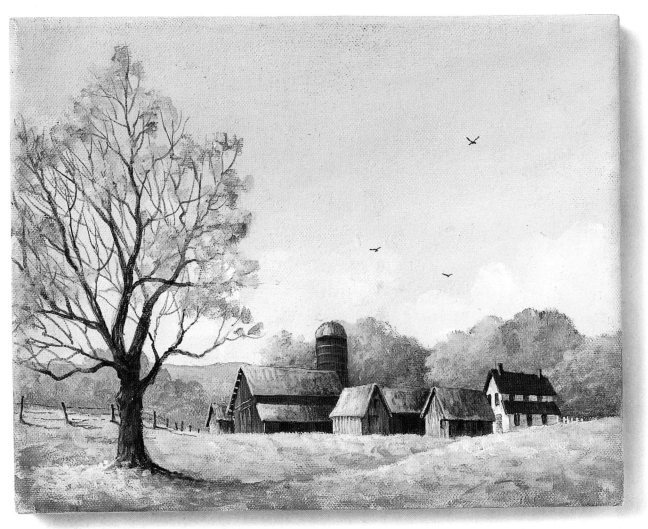

The Farm

Continued from page 111

MATERIALS LIST

Artist Pigment Acrylics:
Alizarin Crimson
Burnt Umber
Hauser Green Light
Prussian Blue
Pure Orange
Red Light
Warm White
Yellow Medium
Yellow Ochre

Brushes:
Flat – #2, #4, #6, #8, #10, #12, #14
Liner – #1
Wash – 1"

Surface:
Canvas, 8" x 10"

COLOR MIXES:

Sky: four parts Warm White + one part Prussian Blue (4:1)

Distant Hills: one part Sky Mix + a touch of Alizarin Crimson (1:touch)

STAGE 1

Sky & Background:

1. Paint the sky with the wash brush and the Sky Mix, using long diagonal strokes as shown.
2. While the paint is wet, swirl on Warm White clouds in the lower portion of the sky area. Let dry. *Refer to* Summer Sky with Clouds *in the "Painting Landscape Elements" section.*
3. Neatly trace and transfer the pattern except the large tree in the foreground.

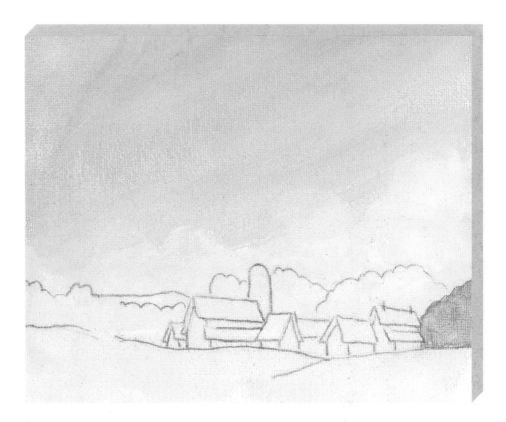

STAGE 2

Block in All Elements:

1. Paint the mountain with the Distant Hills Mix.
2. Dab in the trees behind the barns and on the right side with Hauser Green Light. *Refer to* Distant Spring Trees *in the "Painting Landscape Elements" section.*
3. While the trees are wet, pat on some Yellow Medium at the top of the trees toward their left sides, as shown.
4. Mix one part Sky Mix + one part Yellow Medium (1:1). Paint the trees on the left.
5. Paint the large barn, the distant barn, and the silo with Pure Orange, as shown.
6. Paint the remaining buildings with Warm White.
7. Paint the roof overhangs with Burnt Umber.
8. Paint the roofs, except for the house, with Yellow Ochre.

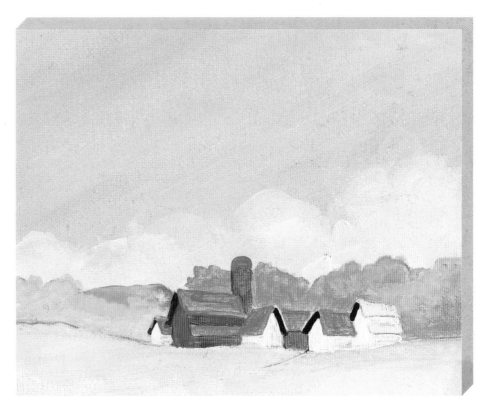

9. Wash the foreground with thinned Yellow Medium. Let dry.

10. Neatly transfer the large foreground tree to the canvas.

Continued on page 114

STAGE 3

Add Details:

1. Darken the bases of the trees to the right with a mixture of one part Hauser Green Light + a touch of Prussian Blue (1:touch).
2. Darken the bases of the trees to the left with a mixture of one part Sky Mix + a touch of Prussian Blue (1:touch).
3. Shade under the roof eaves with thinned Burnt Umber.
4. Shade the dark side of the orange barns with thinned Burnt Umber.
5. Shade the white buildings on their right sides with thinned Burnt Umber.
6. Shade the barn and silo roofs on their right sides with thinned Burnt Umber applied in short, choppy strokes.
7. Paint the roof of the house with Red Light.
8. Shade the roof of the house with a mixture of one part Hauser Green

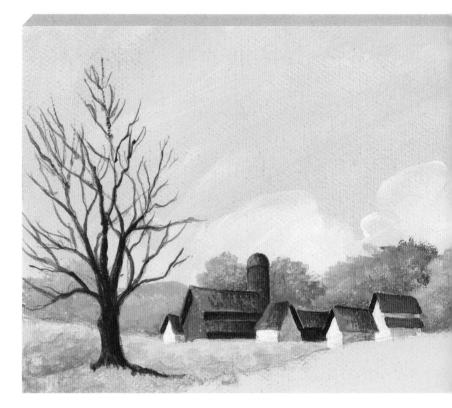

Light + a tiny touch of Prussian Blue (1:touch).
9. Highlight the roof with Yellow Medium and Warm White.
10. Paint the tree trunk and branches with Burnt Umber.

STAGE 4

Refine:

1. Highlight the roofs with a mixture of one part Yellow Ochre + one part Warm White (1:1).
2. Outline the eaves with the liner brush and Yellow Ochre.
3. Shade the roof of the house with thinned Burnt Umber.
4. Paint the details on the buildings with the liner brush and thinned Burnt Umber.
5. Paint the windows and doors with Burnt Umber.
6. To create the leaves on the foreground tree, dab on Hauser Green Light, then shade with the Hauser Green Light + Prussian Blue Mix. Keep the foliage light and airy.
7. Highlight the lower tree trunk with a mixture of one part Warm White + one part Burnt Umber (1:1).
8. Paint the fence posts with the liner brush and thinned Burnt Umber.

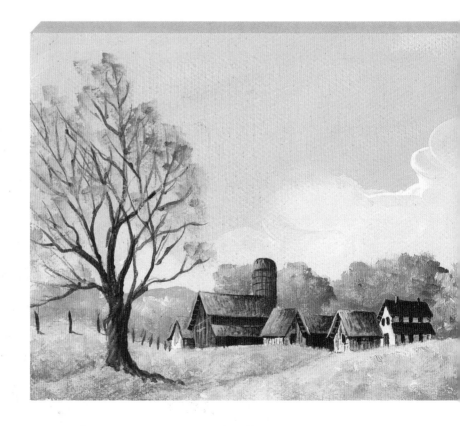

Pattern for The Farm
Actual size

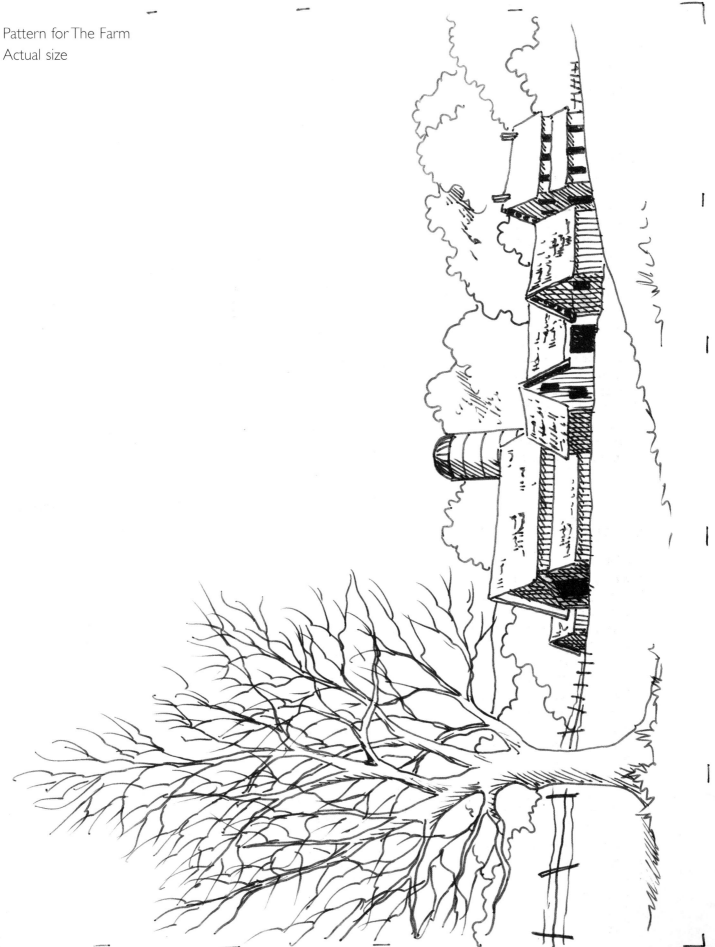

Winter in Wisconsin

Landscapes have many elements in common. You give a painting its unique character by the way you arrange the elements, and how you indicate the time of day and time of year by placing highlights and shadows. There's no need to guess at the season in this little painting!

MATERIALS LIST

Artist Pigment Acrylics:
Asphaltum
Burnt Umber
Prussian Blue
Pure Black
Raw Sienna
Warm White

Brushes:
Flat – #2, #4, #8, #10
Liner – #1
Scrubby or scumbling brush

Surface:
Canvas, 4" x 5"

COLOR MIXES:

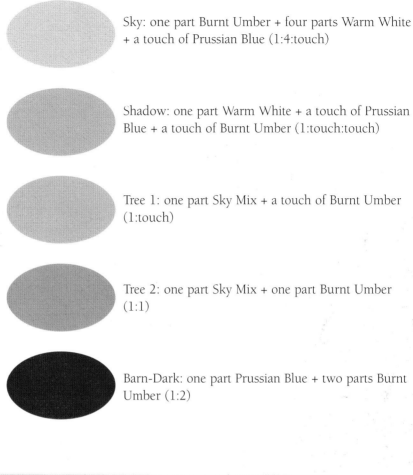

Sky: one part Burnt Umber + four parts Warm White + a touch of Prussian Blue (1:4:touch)

Shadow: one part Warm White + a touch of Prussian Blue + a touch of Burnt Umber (1:touch:touch)

Tree 1: one part Sky Mix + a touch of Burnt Umber (1:touch)

Tree 2: one part Sky Mix + one part Burnt Umber (1:1)

Barn-Dark: one part Prussian Blue + two parts Burnt Umber (1:2)

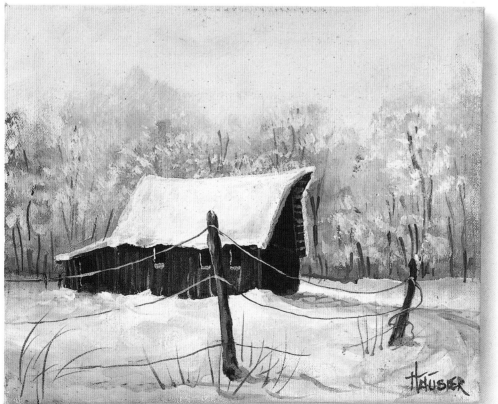

STAGE 1

Sky & Background:

1. Brush Warm White at the bottom of the sky, behind the barn. Put a little of the Sky Mix at the top. Blend the white into the gray and the gray back into the white to create a graded sky. Let dry. *Refer to Snowy Sky in the "Painting Landscape Elements" section.*
2. Neatly trace and lightly transfer the design.
3. Paint the tree area by patting in the Tree 1 Mix. *Refer to Distant Trees in Snow in the "Painting Landscape Elements" section.*
4. While the paint is wet, darken the lower portion of the tree area with Tree 2 Mix.

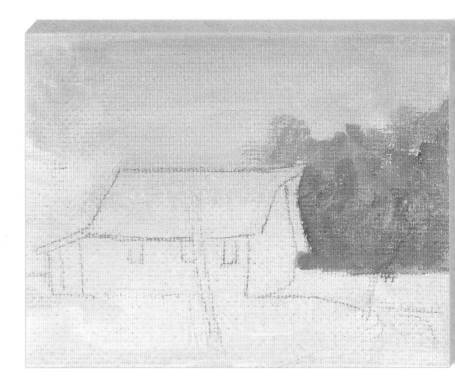

STAGE 2

Block in All Elements:

1. To paint the tree trunks, prepare thinned Burnt Umber and thinned Warm White. Use the liner brush and very fine lines, first with Burnt Umber, then with Warm White, indicating tree trunks as shown.
2. Paint the left side of the barn with Asphaltum.
3. Paint the darker right side of the barn with the Barn-Dark Mix. Let dry.
4. Paint the snowy roof with Warm White.
5. Paint the snowy ground with Warm White.

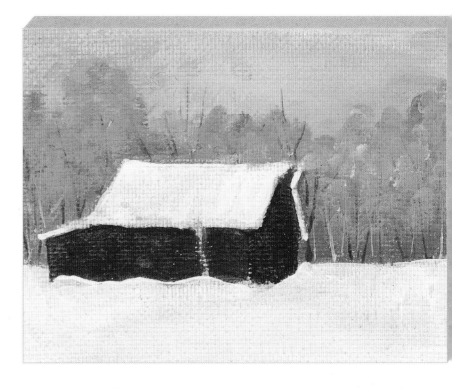

MINI-TIP:

To give the effect of a light dusting of snow: Pick up Warm White with an old, beat-up, flat scrubby brush, and dab it on a rag before lightly dabbing the snow on and over the tree branches.

STAGE 3

Add Details:

1. Shade under the roof on the left side with a float of Burnt Umber.
2. Shade the snow on the ground with the Shadow Mix. Lighten this Shadow Mix by brushing in a bit of Warm White, if needed.
3. Paint the road with this shading color as well.
4. Paint the fence posts with Raw Sienna.
5. Lighten the trees a little by patting on thinned Warm White, then Asphaltum, and then the Sky Mix.

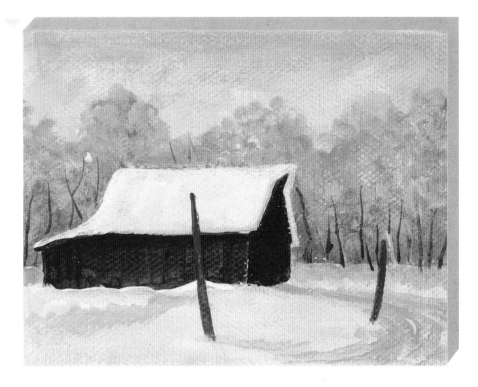

STAGE 4

Refine:

1. Detail the boards on the barn with lines of Burnt Umber. Highlight with Warm White.
2. Paint details under the roof eave with the liner brush and thinned Warm White.
3. Paint the windows and door with Pure Black. Outline or highlight with Warm White on the left of the window frame and on the window sill.
4. Shade the roof with the Shadow Mix.
5. Pat the snow on the trees by dabbing on Warm White with the scrubby brush.
6. Shade the fence posts on the right sides with Burnt Umber.
7. Highlight the posts with thinned Warm White to give the impression of a touch of snow.
8. Paint the wire with the liner brush and thinned Burnt Umber. Highlight the wire with Warm White where it crosses over dark areas.

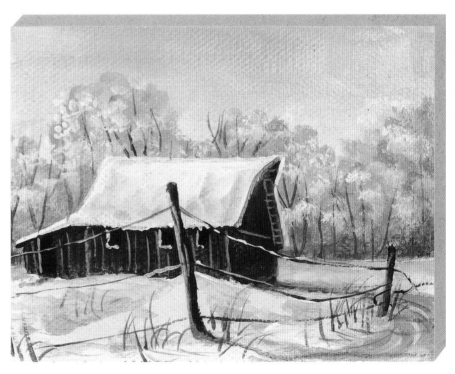

9. Paint the grass with the liner brush and thinned Raw Sienna. Pull strokes up and give them a slight curve as you lift off the canvas. Paint some grass in the shadow area as shown. *Refer to* Grass in Snow *in the "Painting Landscape Elements" section.*
10. Add shadows for the posts and grass with Shadow Mix.

Pattern for Winter in Wisconsin
Actual size

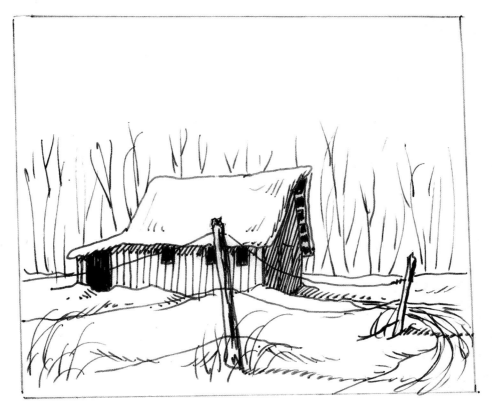

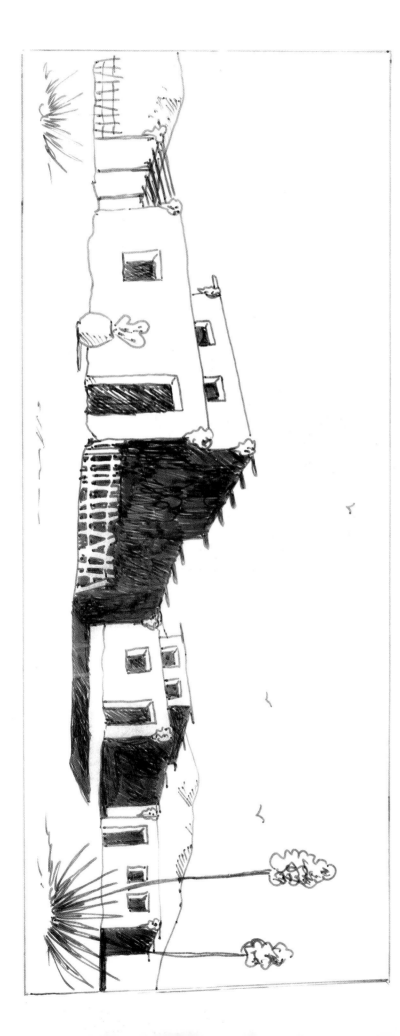

Pattern for Southwest Magic
Actual size
Instructions begin on page 123.

Southwest Magic

Adobe buildings in bright desert sunlight cast very dark shadows, creating a painting with exciting contrasts. The adobe is almost the same color as the rocks and ground, but bundles of fiery chili peppers add touches of hot accent color. The blooming yucca and the potted cactus are easy to paint when you follow the step-by-step painting worksheets for these Southwestern details.

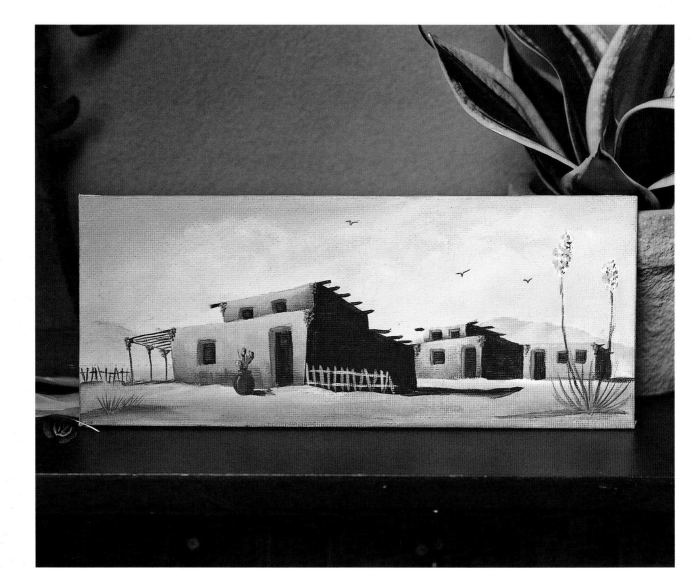

MATERIALS LIST

Artist Pigment Acrylics:
Alizarin Crimson
Burnt Umber
Dioxazine Purple
Hauser Green Medium
Prussian Blue
Pure Orange
Raw Sienna
Warm White
Yellow Medium
Yellow Ochre

Brushes:
Flat – #4, #8, #12
Liner – #1

Surface:
Canvas board, 4" x 10"

COLOR MIXES:

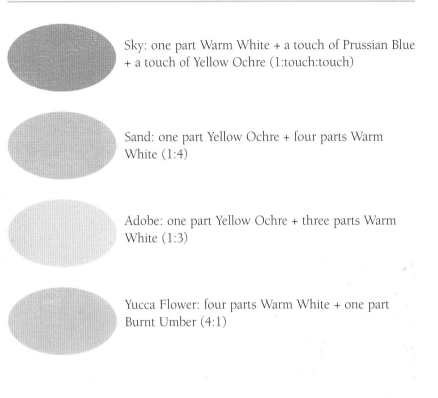

Sky: one part Warm White + a touch of Prussian Blue + a touch of Yellow Ochre (1:touch:touch)

Sand: one part Yellow Ochre + four parts Warm White (1:4)

Adobe: one part Yellow Ochre + three parts Warm White (1:3)

Yucca Flower: four parts Warm White + one part Burnt Umber (4:1)

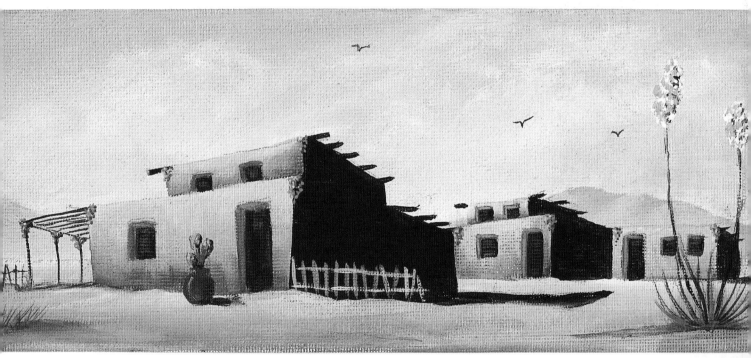

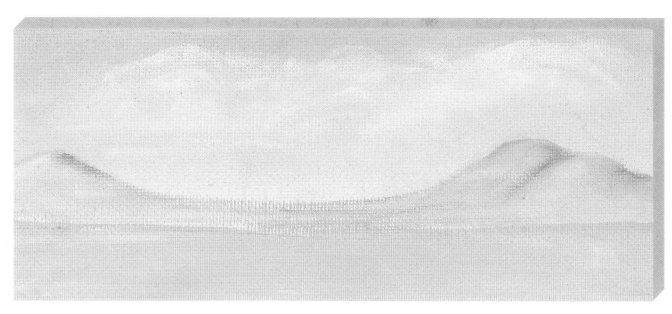

STAGE 1

Sky & Background:

1. Paint the sky with the Sky Mix.
2. While the paint is wet, brush in the clouds with Warm White.

3. Paint the mountains as shown with a mixture of one part Sky Mix + a tiny touch of Dioxazine Purple (1:touch). Shade softly on their right sides with a little extra Dioxazine Purple on the brush.
4. Paint the sand with the Sand Mix. Let dry.

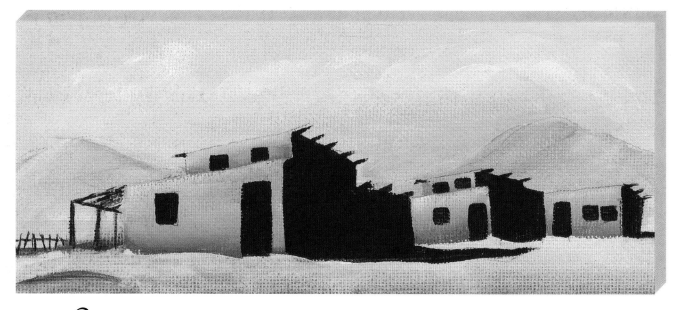

STAGE 2

Block in All Elements:

1. Neatly trace and transfer the design to the canvas.
2. Shade the sand with a float of Raw Sienna.
3. Paint the fronts of the adobe houses with the Adobe Mix.
4. While the paint is wet, darken shading at the base with Raw Sienna, as shown. The foreground house has the darkest shading, and the background house has the lightest shading.

5. Highlight the fronts of the adobe houses at the top with a little Warm White. The foreground house has the brightest highlight, the middle house has less, and the background house has very little highlight.
6. Paint the dark sides of the adobe houses with Burnt Umber.
7. Paint the dark shadow on the sand with Burnt Umber.
8. With Burnt Umber, paint the fence on the left, the lean-to, windows, doors and rafters.

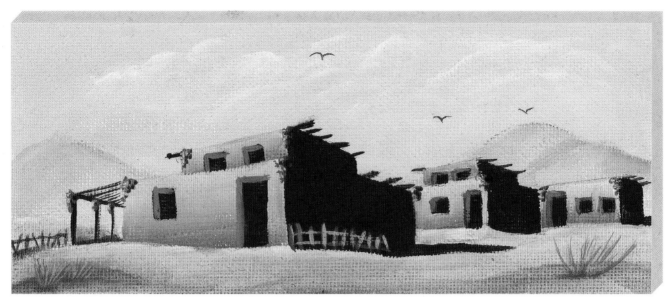

STAGE 3

Add Details:

1. Mix two parts Yellow Ochre + one part Burnt Umber (2:1). Highlight the left side and top of the windows.
2. Paint the fence in the center, using the liner brush and the mixture above.

3. Paint the peppers with dots of Pure Orange. While wet, shade with dots of Alizarin Crimson and highlight with dots of Yellow Medium. Use large dots on the peppers hanging on the foreground house, and tiny dots for those on the background house.
4. Paint the birds with thinned Burnt Umber.

Potted Cactus Details:

1. Paint the cactus with Hauser Green Medium.
2. Shade with Burnt Umber.
3. Highlight with a little Warm White.
4. Paint the pot with Raw Sienna.

5. Shade with Burnt Umber.
6. Highlight with a mixture of one part Yellow Ochre + four parts Warm White (1:4).

Continued on page 126

Yucca Details:

1. Paint the yucca stems with thinned Burnt Umber.
2. Using the liner brush, dab on Warm White for flowers. Add dots with the Yucca Flower Mix.
3. Dot dark shading into the flowers with a mixture of one part Burnt Umber + one part Prussian Blue + one part Warm White (1:1:1).
4. Paint the blades of grass with Hauser Green Medium.
5. Shade with a mixture of Hauser Green Medium + Burnt Umber.
6. Highlight the grass with a mixture of one part Hauser Green Medium + three parts Warm White (1:3).

Metric Conversion Chart

Inches to Millimeters and Centimeters

Inches	MM	CM	Inches	MM	CM
1/8	3	.3	2	51	5.1
1/4	6	.6	3	76	7.6
3/8	10	1.0	4	102	10.2
1/2	13	1.3	5	127	12.7
5/8	16	1.6	6	152	15.2
3/4	19	1.9	7	178	17.8
7/8	22	2.2	8	203	20.3
1	25	2.5	9	229	22.9
1-1/4	32	3.2	10	254	25.4
1-1/2	38	3.8	11	279	27.9
1-3/4	44	4.4	12	305	30.5

Yards to Meters

Yards	Meters	Yards	Meters
1/8	.11	3	2.74
1/4	.23	4	3.66
3/8	.34	5	4.57
1/2	.46	6	5.49
5/8	.57	7	6.40
3/4	.69	8	7.32
7/8	.80	9	8.23
1	.91	10	9.14
2	1.83		

Index